Images of Modern America

ROUTE 6
IN PENNSYLVANIA

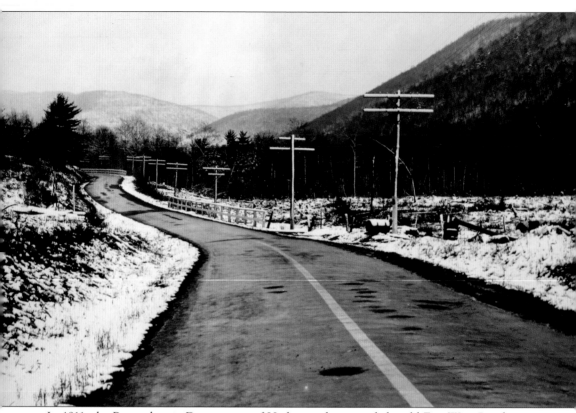

In 1911, the Pennsylvania Department of Highways designated the old East-West Road across northern Pennsylvania as a "state road," laying the foundation for its subsequent improvement, and marking as part of transcontinental US Route 6. As seen in this snowy November image taken in 1927, the road was threaded through the upper Pine Creek Valley to cross the high Allegheny Plateau in Potter County. (Pennsylvania Historical and Museum Commission State Archives.)

FRONT COVER: A Pennsylvania section of transcontinental US Route 6 in Erie County, just west of Union City, is pictured at sunset in 1938. (Authors' collections.)

UPPER BACK COVER: This US 6 Roosevelt Highway Association map shows transcontinental Route 6 crossing northern Pennsylvania in 1938. (Authors' collections.)

LOWER BACK COVER: **(left)** Village Diner along US 6 east of Milford, Pennsylvania; **(center)** a c. 1949 U.S. 6 Roosevelt Highway Association brochure; **(right)** Route 6 along the North Branch of the Susquehanna River in Standing Stone Narrows, east of Wysox, Pennsylvania. (All, authors' collections.)

Images of Modern America

ROUTE 6
IN PENNSYLVANIA

Kevin J. Patrick
Elizabeth Mercer Roseman
Curtis C. Roseman

ARCADIA
PUBLISHING

Published by Arcadia Publishing
Charleston, South Carolina

Printed in the United States of America

Library of Congress Control Number: 2016953982

For all general information, please contact Arcadia Publishing:
Telephone 843-853-2070
Fax 843-853-0044
E-mail sales@arcadiapublishing.com
For customer service and orders:
Toll-Free 1-888-313-2665

Visit us on the Internet at www.arcadiapublishing.com

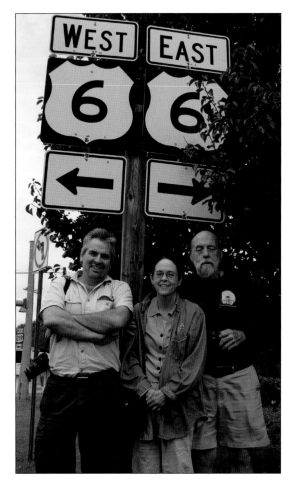

Kevin J. Patrick (left), Elizabeth Mercer Roseman, and Curtis C. Roseman explore Route 6 in Lantz Corners, Pennsylvania. (Authors' collections.)

CONTENTS

Acknowledgments 6

Introduction 7

1. Assembling Route 6 9

2. Route 6 Road Trip East 23

3. Route 6 Road Trip West 51

4. Route 6 Towns 75

Bibliography 95

ACKNOWLEDGMENTS

This book is dedicated to John Jakle, whose passion for the highway and roadside has been an inspiration to us.

During our travels on Route 6, we met many people who are very enthusiastic about the history, landscapes, and roadside features of Route 6 in Pennsylvania. They welcomed us to their communities and were willing to answer our questions and assist us in finding resources regarding the highway. To these people and organizations, we extend our sincere thanks: Pennsylvania Historical and Museum Commission State Archives (PHMC) in Harrisburg; Pike County Historical Society, Milford; Wayne County Historical Society, Honesdale; Lackawanna Historical Society, Scranton; Gina Evans of the Wyoming County Historical Society, Tunkhannock; the staff of the Bradford County Historical Society, Towanda; Joyce Tice of the History Center on Main Street, Mansfield Tioga County Historical Society, Wellsboro; Jennifer Rossman of the Pennsylvania Route 6 Alliance, Galeton; Potter County Historical Society, Coudersport; Dan and Karen Parson of the Lindy Motel and Cottages, Coudersport; McKean County Historical Society, Smethport; Warren County Historical Society, Warren; Historical Society of Erie County, Erie; the staff of the Union City Area Historical Museum, Union City; and the Crawford County Historical Society, Meadville. Special thanks go to our Route 6 traveling companion Stacey Patrick.

Unless otherwise indicated, images are from the authors' shared collections, combined for use in this book.

The Curt Teich postcards are from the authors' collections. An entire collection of Curt Teich postcards was formerly archived at the Lake County Discovery Museum in Wauconda, Illinois. It is currently being transferred to the Newberry Library in Chicago, Illinois.

The collection of Tichnor postcards is available at Digital Commonwealth of the Boston Public Library in Boston, Massachusetts.

INTRODUCTION

Pennsylvania's Route 6 does not follow the well-beaten path of wagon roads, canals, and railroads that were hammered across the Appalachian Mountains in the 19th century, on which modern turnpikes and interstate highways were grafted in the 20th century. Route 6 is outside the main trans-Appalachian transportation corridors that emerged to link the great Atlantic Seaboard cities to a burgeoning West across the mountains. These corridors commandeered the easiest paths through lowland valleys and water gaps, shunning the long and lonely route across northern Pennsylvania's Endless Mountains. Westbound New York City traffic favored the Hudson-Mohawk Lowland, an L-shaped corridor following the Hudson Valley to Albany, then west up the Mohawk River and onto the Lake Ontario Plain to Buffalo. Well north of Route 6, the Erie Canal, New York Central Railroad, US 20, and the New York State Thruway followed each other through this corridor. South of Route 6, the Pennsylvania Main Line Canal, Pennsylvania Railroad, Lincoln Highway (US 30), William Penn Highway (US 22), and Pennsylvania Turnpike tracked west from Philadelphia across the folded ridges and valleys of the Appalachian Mountains to Pittsburgh and beyond.

The vast Appalachian Plateau, cut up into a labyrinth of steep-sided stream valleys and cloaked-in expansive forests, stretched across the empty space between the Hudson-Mohawk Lowland and southern Pennsylvania. No trans-Appalachian canal or railroad pioneered the path through the wilds of northern Pennsylvania for Route 6. To be sure, the original alignment was marked out over preexisting 19th-century wagon roads with many miles in sight of paralleling railroads and even a few stretches adjacent to defunct canals, but none that defined a transportation corridor the whole way across the state. Even though US 6 was established as a transcontinental highway stretching from Provincetown, Massachusetts, to Long Beach, California, traffic through the small towns of Pennsylvania's northern tier attracted no paralleling interstate highway any closer than Interstate 86, thirty miles north, or Interstate 80, fifty miles south.

The backwater character of Pennsylvania's Route 6 is exactly what road is all about. The more historically significant federal highways from the pre-interstate era—roads like US 30, US 40, and the celebrated US 66—all had their day of traffic-choked importance and then were bypassed. Pennsylvania's Route 6, however, having no close interstate alternative still functions as Main Street through the northern tier—literally. Route 6 is the Main Street through Matamoras, Milford, Hawley, Honesdale, Towanda, Troy, Mansfield, Wellsboro, Galeton, Coudersport, Port Allegany, Smethport, Mount Jewett, Kane, Union City, Conneaut Lake, Linesville, and many other smaller burgs surviving the 21st century without the benefit of a bypass. The Route 6 travel experience is not merely a window on a historically preserved and polished slice of midcentury America, it is a living, evolving entity that still functions as it did 60 years ago.

The first incarnation of Route 6 began soon after settlement, when pioneers hacking a living out of the remote forests of northern Pennsylvania became numerous enough to require a new tier of counties through which the state legislature authorized a wagon road to connect the county seats.

After Wayne County formed in 1798, Crawford, Erie, and Warren Counties were all established on March 12, 1800, followed by McKean, Potter, and Tioga Counties on March 26, 1804. Bradford County was founded in 1810, followed by Pike County in 1814. Late-generation Wyoming and Lackawanna Counties were created from Luzerne County in 1842 and 1878, respectively. The road that connected the county seats of this newly established tier was simply known as the East-West Road. The East-West Road was surveyed and built between 1806 and 1809. It struck west from Montrose, soon to be the seat of Susquehanna County, and passed through the county seats of Towanda, Wellsboro, Coudersport, Smethport, and Warren to a terminus in Erie. In Montrose, the East-West Road intersected with the Milford and Owego Turnpike, which angled between the Pike County seat of Milford to Owego, New York, by way of the Wayne County seat in Honesdale. Other roads were subsequently built to provide a more direct path than the route through Montrose. The rise of Scranton as a major city, surrounded by a galaxy of coal mines and mills, pulled the main road across northern Pennsylvania into the Lackawanna Valley and along the North Branch of the Susquehanna River to Towanda. This was the established way when US 6 was routed across the state in 1928.

Railroads that came to serve the towns of the old East-West Road did not push across the mountains from east to west but were extended across the region from north to south, particularly to move Pennsylvania lumber and coal to New York and the Great Lakes. From these trunk railroads, branch lines and small railroads like the Coudersport & Port Allegany and the Buffalo & Susquehanna sent tendrils of steel rail along the East-West Road and into the mountain towns that would eventually be served by Route 6. The railroads superseded the wagon roads for long-distance travel, causing the roads to become a largely neglected and poorly maintained network of local farm-to-market roads until the early 20th century, when Route 6 was assembled to span northern Pennsylvania's Appalachian Plateau.

One

ASSEMBLING ROUTE 6

In 1903, the needs of the automobile triggered the creation of the Pennsylvania Department of Highways, which, in 1911, took over 8,000 miles of neglected wagon roads to rebuild and maintain as a primary network of state roads designed to connect every county seat in the commonwealth. Having originally been established to connect the northern tier county seats, the East-West Road was absorbed into this network and rebuilt with macadam. As cars became faster and more numerous, road improvement projects created new alignments of straighter, better-graded highway. Once bypassed, remnant bits of original road that did not continue to carry the name of the place they went to (like Old Milford Road, Owego Turnpike, Honesdale Road, Old Mainesburg Road, Old Bush Mill Road, Old Smethport Road, or Old Pittsfield Road) were commonly named Old State Road.

Dependable automobiles and publicly funded highways presaged the possibility of long-distance motoring but only if a reliable wayfinding system of well-signed routes was established over a network of all-weather roads. Before the state and federal government took up this challenge, private highway associations were formed by local chambers of commerce and cadres of businessmen to name, sign, and coerce improvements on certain pet highways linking towns and regions that stood to benefit from the increase in traffic. To generate popular appeal, many of these roads were named after the great and heroic, like Lincoln Highway, Jefferson Highway, Lee Highway, and across northern Pennsylvania, the Roosevelt Highway. Populist Teddy Roosevelt died in 1919 at the height of the private auto trail rage and, therefore, was honored with more than his fair share of roads. Within a month of his death, the Theodore Roosevelt International Highway Association was founded to mark out a road from Portland, Maine, to Portland, Oregon. The transcontinental Midland Trail, laid out by American Automobile Association pathfinder A.L. Westgard in 1912, merged with a fledgling Roosevelt National Highway mapped across New York from Long Island to Buffalo to become the Roosevelt Midland Trail. None of these crossed Pennsylvania's northern tier.

Pennsylvania's Roosevelt Highway resulted from a 1923 state law that gave the power to name and number highways solely to the Pennsylvania Department of Highways (DOH). This was done to end the confusion caused by dozens of private highway associations that named, marked, and then often relocated routes passing through the state. In 1924, the DOH introduced a network of cross-state highways that included nine named routes. Some, like the Lincoln Highway across the southern part of Pennsylvania and the William Penn Highway farther north, legitimized preestablished names and routes. Others used names and routes designated by the DOH. The Roosevelt Highway, incorporating the old East-West Road between Matamoras and Erie, was

named by newly elected governor Gifford Pinchot, whose family estate, Grey Towers, was in Milford. The name honored his friend, the late president under whom he served as the first director of the US Forest Service.

Pennsylvania's named highways were simultaneously numbered using a DOH system where odd numbered roads ran east-west and even numbered roads north-south in the opposite direction of the national system adopted by the American Association of State Highway Officials (AASHO) in 1926. In Pennsylvania, the Lincoln Highway was State Route 1, the William Penn Highway was Route 3, the Lakes-to-Sea Highway was Route 5, and the Roosevelt Highway was Route 7. In the AASHO system of federal routes, US 30 was marked along Pennsylvania's part of the Lincoln Highway and the William Penn Highway became synonymous with US 22. This national interstate system also had a US 6 that crossed southern New England from Provincetown, Massachusetts, at the tip of Cape Cod, to Brewster, New York. In 1928, US 6 was extended west across the Hudson River and over Pennsylvania's Roosevelt Highway to Erie. The expense of double marking these highways with state and federal route shields caused the DOH to abandon its original numbering scheme in the 1930s. Federal Route 6 was extended west to Greeley, Colorado, in 1931 by rerouting it away from Erie and through Meadville. In 1937, US 6 was extended to Long Beach, California, creating the longest transcontinental highway in the federal route system until it was cut back to Bishop, California, in 1964.

A twist in the identity of Route 6 occurred with the 1932 founding of the US 6 Roosevelt Highway Association in Scranton, Pennsylvania. Unlike the earlier highway associations whose intent was to promote the building of long-distance automobile roads, this association emphasized travel and tourism on roads already built and actively being improved as a result of federal highway legislation in 1916 and 1921. Publicly funded roads were now assured and incorporated into a national system of numbered highways that hastened the demise of the auto trails associations and the fading of their nurtured routes, including the Theodore Roosevelt International Highway and the Roosevelt Midland Trail. In their absence, this new organization spread the identity of the Roosevelt Highway across the country with the western extensions of US 6 over an alignment that now crossed and, in fact, originated from northern Pennsylvania.

The US 6 Roosevelt Highway Association promoted the road in Pennsylvania through the free distribution of maps by the Scranton Chamber of Commerce, under the leadership of Raymond Gibbs. After US 6 reached the shores of the Pacific Ocean in 1937, a transcontinental map of the route was distributed through the chamber of commerce in Des Moines, Iowa, through the association secretary, Alexander Fitzhugh. On its maps and brochures, the US 6 Roosevelt Highway Association also disseminated a new identity for the road: the Grand Army of the Republic (GAR) Highway. The GAR moniker was not a promotional device for road building or tourism, but an honorary memorial to the soldiers who fought to preserve the Union during the Civil War. The idea to apply this commemorative title to US 6 was conceived by US Army major William Anderson Jr. in 1934. Anderson gained the support of the Sons of Union Veterans who petitioned the state highway departments along US 6. Anderson's home state of Massachusetts was the first to make the GAR dedication for its piece of US 6 in 1937, followed by California in 1943, Indiana in 1946, and Pennsylvania in 1948. The remaining US 6 states were on board by the time of the official dedication of the transcontinental Grand Army of the Republic Highway at the western terminus of US 6 in Long Beach, California, on May 3, 1953.

With the dedication of the Grand Army of the Republic Highway, the form and identity of Pennsylvania's mid-20th-century Route 6 was complete. For almost 20 years, the time period emphasized in this book, Route 6 was the main road across the Appalachian Mountains midway between the Pennsylvania Turnpike and the New York State Thruway. Ironically, 1953 was also the year the Delaware Water Gap Bridge opened as the first link in what would become the Keystone Shortway, Pennsylvania's part of transcontinental Interstate 80. Completed in 1970, Interstate 80 would eventually overshadow Route 6, preserving its mid-20th-century characteristics for a future generation of back roads explorers to discover.

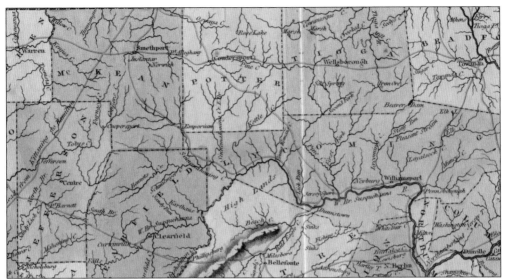

The first road across northern Pennsylvania's Allegheny Plateau was constructed as the East-West Road between 1806 and 1809 to connect the governmental seats of a new tier of counties established along the New York border. This 1822 map of Pennsylvania shows the central part of the East-West Road forerunner to Route 6, which was built between Erie and Montrose, where it intersected with the Milford and Owego Turnpike to Milford. (Mapsofpa.com.)

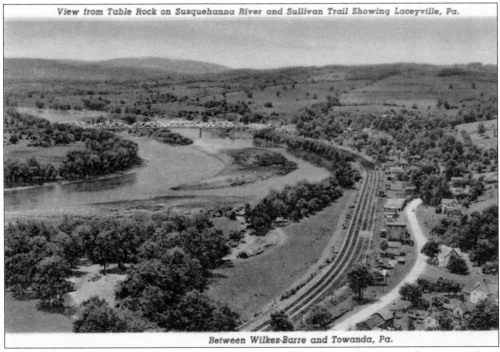

Route succession along northern Pennsylvania's Route 6 corridor is well expressed at Laceyville in the Susquehanna River Valley. The North Branch Canal, opened in 1856, was bought by the Lehigh Valley Railroad in 1866 and replaced with tracks that were followed by the Roosevelt Highway in 1924 (to the right of the railroad), which became part of US 6 in 1928. (Curt Teich postcard.)

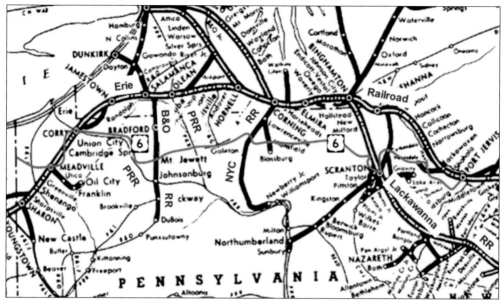

The major trans-Appalachian railroads avoided the route taken by US 6 (red line) across the high part of the Allegheny Plateau. The Erie Railroad was closest crossing through southern New York and paralleled parts of US 6 in northwestern Pennsylvania. Most other railroads serving Route 6 towns ran north-south to access Pennsylvania's coal fields or angled alongside US 6 for short stretches, like the Lehigh Valley Railroad along the Susquehanna River and the Pennsylvania Railroad in Warren County.

Route 6 parallels the old Erie Railroad Main Line (between New York City and Chicago) from Columbus in Warren County to Meadville via Corry, Union City, and here, a moonlit Cambridge Springs, which the Erie promoted as a mineral springs resort. To strengthen its position against the midcentury onslaught of the automobile, the Erie merged with the Delaware, Lackawanna & Western to form the Erie-Lackawanna Railroad in 1960.

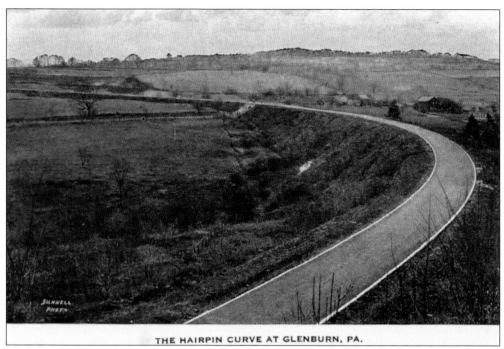

THE HAIRPIN CURVE AT GLENBURN, PA.

The Lackawanna Trail shown above at the Glenburn Hairpin Curve was built over the top of the original Delaware, Lackawanna & Western Railroad opened north from Scranton in 1851. The railroad was relocated to a better alignment over the Tunkhannock Viaduct in 1915, and its old course was rebuilt as an early auto trail. The trail was considered to be too narrow and outdated by 1928, and US 6 avoided it, following instead the road west from Clark Summit through Lake Winola to Tunkhannock. Route 6 was relocated to the four-lane superhighway shown below when it was built to bypass the old Lackawanna Trail between Clark Summit and Factoryville.

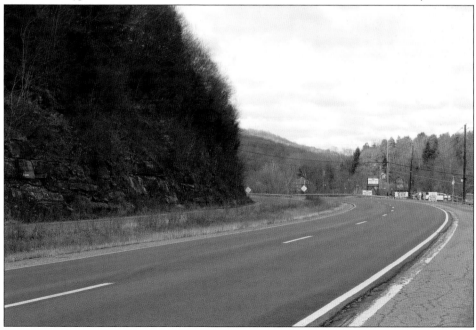

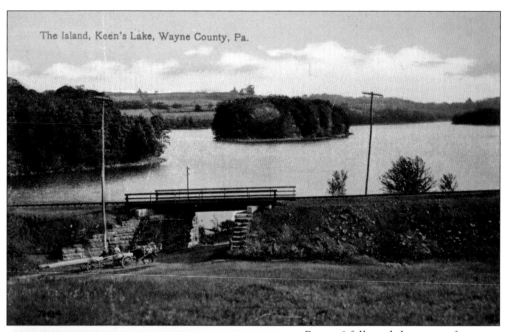

The Island, Keen's Lake, Wayne County, Pa.

Route 6 followed the route of the Delaware & Hudson Gravity Railroad that carried New York City–bound coal over Moosic Mountain from Carbondale to the Delaware & Hudson Canal in Honesdale. From 1829 until replaced by a steam railroad in 1899, loaded coal cars rolled across this bridge spanning Keen Lake Road east of Waymart. The road became part of Route 6 in 1928. During the 1930s, the railroad was abandoned and a new alignment was built for Route 6 bypassing Keen Lake Road and the village of Waymart.

Like the gravity railroad, Route 6 entered Carbondale after descending the west slope of Moosic Mountain from Rix's Gap, passing what is now Gravity Park at the old base of Inclined Plane No. 1. The Delaware & Hudson Railroad erected this shaft here in 1913 to commemorate the old line and America's first steam locomotive, the English-made *Stourbridge Lion*, that traversed it in 1829.

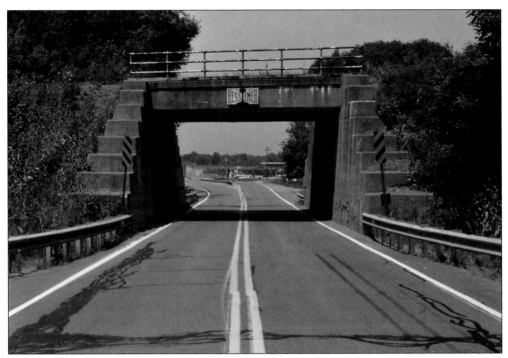

The north-south rail lines that crossed Route 6 include the Bessemer & Lake Erie Railroad (B&LE) and the Kinzua branch of the Erie Railroad. The B&LE still carries Great Lakes iron ore south to Pittsburgh steel mills and Pennsylvania coal back to the Great Lakes. Here, the B&LE overpass spans US Route 6N just east of its terminus with US Route 20 in West Springfield (seen above). The Erie line was also built to tap Pennsylvania bituminous coal, crossing US Route 6 at Mount Jewett just south of the Kinzua Bridge (seen below). Once the highest bridge in Pennsylvania, Kinzua opened as an iron span in 1882, was rebuilt with steel in 1900, and was destroyed by a tornado in 2003. Part of the bridge left standing was converted into the Kinzua Skywalk pedestrian overlook in 2011.

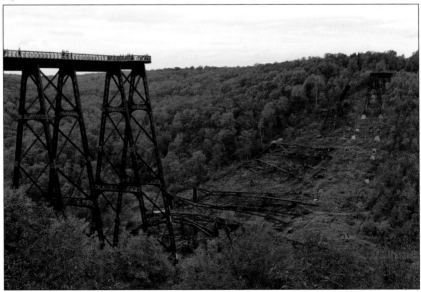

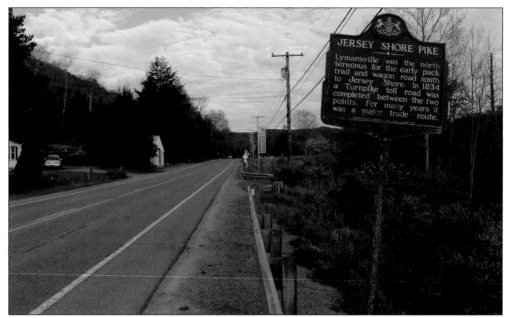

The Jersey Shore Pike marker on Route 6 near New Sweden shows that the north-south trend to historic transportation routes serving northern Pennsylvania predated the railroads. This remote part of the state was largely settled and supplied from the south over trails and roads that entered the Pennsylvania wilds from Jersey Shore, Williamsport, and Sunbury in the settled Susquehanna Valley. Following its East-West Road precursor, Route 6 cuts across this older travel orientation.

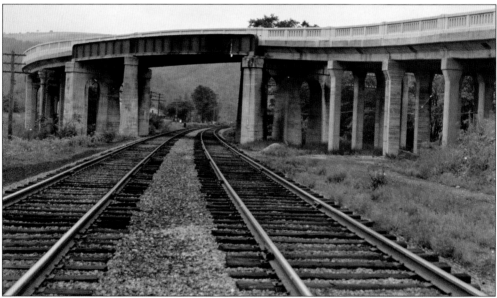

Railroads built before the age of the automobile had many grade crossings where paralleling roads crossed the tracks over tight S-curves. These were replaced by S-curve bridges, like this US Route 6 span built over the Pennsylvania Railroad and New York Central Railroad east of Youngsville in 1934. The tight curves on the S-bridges themselves proved to be dangerous as vehicle speeds and volumes increased, and this one was replaced by a span with broader curves in 1969. (PHMC.)

The last first-generation S-curve grade separation on US Route 6 in Pennsylvania is this underpass beneath the old Erie Railroad Main Line at Columbus in Warren County. Before the 1930s, pre–Route 6 went straight before turning right to cross the tracks at grade, entering Columbus from the south.

New alignments were also built to eliminate multiple railroad grade crossings by relocating the entire highway to one side of the tracks. A new alignment was built north of the Pennsylvania Railroad between Youngsville and Pittsfield in the mid-1920s to eliminate two grade crossings on the Old Pittsfield Road. Route 6 originally followed West Main Street into Youngsville until the building of the Youngsville-Irvine Bypass in 1969.

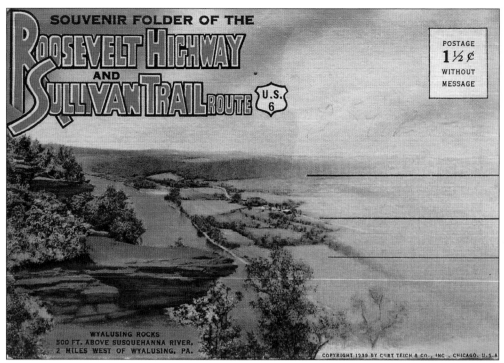

SOUVENIR FOLDER OF THE
ROOSEVELT HIGHWAY
AND
SULLIVAN TRAIL ROUTE U.S. 6

POSTAGE
1½¢
WITHOUT
MESSAGE

WYALUSING ROCKS
500 FT. ABOVE SUSQUEHANNA RIVER,
2 MILES WEST OF WYALUSING, PA.

COPYRIGHT 1939 BY CURT TEICH & CO., INC., CHICAGO, U.S.A

Before route-numbering systems, long-distance roads were created by identifying them with a name motorists could follow. The Pennsylvania Department of Highways named the state road across northern Pennsylvania after Teddy Roosevelt in 1924, four years before US Route 6 was marked over it from Brewster, New York, to Erie. It overlapped the Sullivan Trail along the Susquehanna River between Osterhout and Towanda. (Curt Teich postcard.)

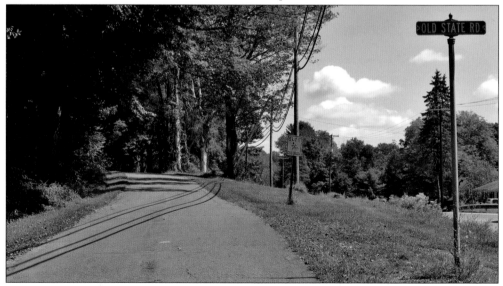

Each new alignment built for Route 6 bypassed an older parallel remnant that frequently came to be known by the road's previous name prefixed by "Old." Old Roosevelt Highway, Old Route 6, Old Milford Road, Old Bush Mill Road, and Old Smethport Road all define remnants of either old Route 6 or pre–Route 6, as does the Old State Road east of Prompton in Wayne County.

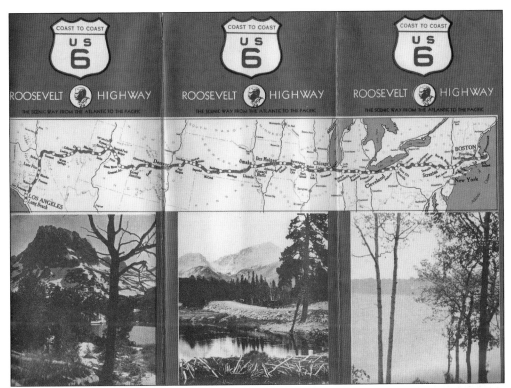

The US 6 Roosevelt Highway Association was founded in Scranton, Pennsylvania, with an office in Des Moines, Iowa, soon after Route 6 was extended from Greeley, Colorado, to Long Beach, California, in 1937. The association propelled the Roosevelt Highway name to transcontinental status. This brochure emphasizes the transcontinental nature of Route 6 and promoted tourist travel over the road.

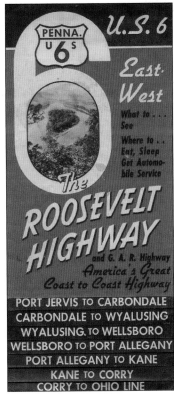

Around 1949, the US 6 Roosevelt Highway Association of Pennsylvania produced this Route 6 trip-tick map with suggestions on what to see and where to stop for gas, food, and lodging. It also defined US Route 6 as "America's Great Coast to Coast Highway" and the Grand Army of the Republic (GAR) Highway honoring Union soldiers who fought in the Civil War. Pennsylvania designated its portion of Route 6 as part of the GAR Highway in 1948; the remaining Route 6 states, by 1953.

The Route 6 corridor across northern Pennsylvania is an intertwined braided stream of historic transportation routes, as seen in this view of East Brick Road in Kanesholm, McKean County. A 1920s-era brick-paved remnant sits between a Route 6 roadway built in the 1930s and an abandoned branch of the Baltimore & Ohio Railroad (left).

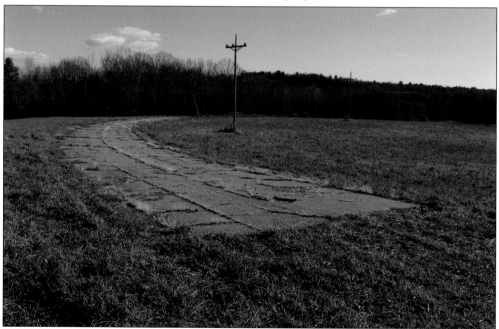

Concrete was the favored road building material throughout the mid-20th century as preserved in this abandoned arc of old Route 6 on the plateau surface between Bradford County's Wyalusing Rocks and the French Azilum Overlook. This old remnant near Cross Road on Lime Hill was used into the 1960s before being bypassed by the current US 6 alignment.

This 1951 Pennsylvania Department of Highways photograph captures modern Route 6 at midcentury showing a two-lane bypass around the village of Prompton in Wayne County. Motorist services like this Mobilgas station called out to travelers with nationally recognized corporate symbols, and there were few more famous than Mobil's Pegasus. The trade name Mobilgas was eventually shortened to Mobil. (PHMC.)

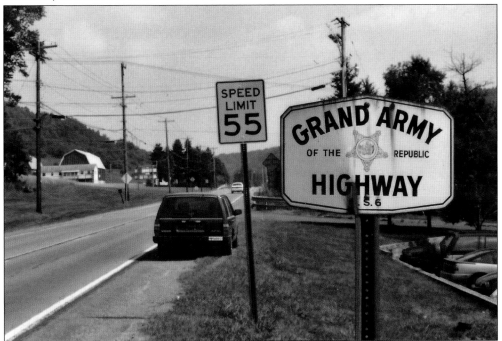

This 1999 photograph shows an old GAR sign at Sweden Valley in Potter County. In 1934, US Army general William Anderson Jr. proposed this commemorative designation for transcontinental US Route 6. Pennsylvania adopted the Grand Army of the Republic name in 1948, and the entire road from Cape Cod to California was marked as the GAR Highway by 1953.

By the late 1930s, new straighter, wider, multilane highways built with substantially more cuts, fills, and overpasses were starting to garner a name befitting their beefier stature: *superhighway*. The Scranton-Carbondale Superhighway, shown here in a view looking north across the Lackawanna Valley to Moosic Mountain, opened on July 25, 1941, bypassing a string of coal towns that US 6 previously meandered through, including Mayfield, Jermyn, Archbald, Blakely, and Dickson City.

The 1930s superhighway seemed quaint by the 1969 opening of the Youngsville-Irvine Bypass, the first limited-access expressway on Route 6 in Pennsylvania. By then, superhighway standards were set by the US Interstate Highway System. This was the last stretch of limited-access expressway built for Route 6 in Pennsylvania until the relocation of US 6 from the Scranton-Carbondale Superhighway to the Governor Casey Highway in 1997.

Two

ROUTE 6 ROAD TRIP EAST

The pattern of mid-20th-century Pennsylvania's Route 6—its hills and valleys, roads and rivers, towns and country—has resulted from a layered interface between the natural environment, historical events, and overlapping cultural landscapes. The same prominent peaks and valleys known by Route 6 residents and travelers today were familiar to the first settlers who pushed into the forests of northern Pennsylvania two centuries ago, as well as to the Indians of the region centuries before that. Even now, the experience of "Doing 6"—a tourist slogan that suggests the 370-mile scenic drive is a destination in itself—is rooted to the landscapes the highway traverses. Nearly the entire length of Pennsylvania's Route 6 crosses the Appalachian Plateau, which was pushed up with North America's collision with Africa some 300 million years ago and then dissected by streams carving valleys into it ever since. This erosion was aided over the last million years by repeated glaciation, which has rounded the hills and broadened the valleys in the east while burying the flatter landscapes to the west in glacial tills. The last of the glaciers receded 10,000 years ago without ever reaching the higher central part of the plateau, where US 6 threads through a forested landscape of deep gorges and knobby hilltops now known as the Pennsylvania Wilds.

After crossing the Delaware River between Port Jervis, New York, and Matamoras, Pennsylvania, US 6 was routed down the broad trough of the Delaware Valley for a dozen miles to Milford, skirting the base of the Pocono Plateau, which rises as a wooded rampart to the west. Traffic follows the roadway built just before World War II as a three-lane bypass of the Old Milford Road. Route 6 turns west at Milford ascending the Pocono Plateau where timbering was the mainstay of the economy before the railroads brought the first tourists to the region in the 19th century. By the mid-20th century, the Poconos were already famous as a mountain resort of summer cottages, fall hunting, and winter skiing for megalopolitans from New York City and Philadelphia. This pattern follows Route 6 across the breadth of the Appalachian Plateau. Places not conducive to farming are a mix of timbering and tourism.

Route 6 passes Lake Wallenpaupack on the western side of the Poconos before dropping into the Lackawaxen Valley and through the towns of Hawley and Honesdale. Tributary to the Delaware, the Lackawaxen River was an early pathway for New York City–bound coal shipped out of the Lackawanna Valley by way of the Delaware & Hudson Canal and Gravity Railroad. Route 6 west of Honesdale follows the path of the old gravity railroad over Moosic Mountain, the upturned eastern rim of the Lackawanna Valley, and into Carbondale.

The Lackawanna Valley is the northern part of a 70-mile long, banana-shaped trough that carries the name Wyoming Valley, south of where the Lackawanna River flows into the North

Branch of the Susquehanna. This is coal country. From 1822 to about 1960, anthracite mining laid the foundation for a galaxy of industrial cities, and coal patches centered on Scranton and Wilkes-Barre. It was also responsible for the string of coal patch towns the original US 6 was routed through between Carbondale and Scranton that included Jermyn, Archbald, Blakely, and Dickson City. This route was bypassed by the four-lane Scranton-Carbondale Superhighway (now Business 6) in 1941, which lost the US 6 shield to the new Governor Casey Highway in 2004. The superhighway terminated at the North Scranton Circle where US 6 turned west through Leggetts Gap, climbing out of the Lackawanna Valley and up to Clarks Summit over another four-lane superhighway stretch opened in 1938.

Up until 1953, US 6 traffic westbound from Clarks Summit continued to Tunkhannock by way of Lake Winola and Osterhout (now Pennsylvania Routes 307 and 92). Federal Route 11, running concurrent with US 6 from the North Scranton Circle, originally followed the old Lackawanna Trail north through Factoryville using the right-of-way abandoned by the Delaware, Lackawanna & Western Railroad in 1915. The Old Lackawanna Trail to Factoryville was bypassed by a four-lane highway in the early 1950s as part of the US 6 rebuild between Clark Summit and Tunkhannock that relocated the route away from Lake Winola. This completed the midcentury reconstruction of Route 6 through Lackawanna County that converted it into a four-lane superhighway from Carbondale to Factoryville.

Route 6 from Tunkhannock to Towanda parallels the North Branch of the Susquehanna River taking shortcuts over ridge backs where the river swings away from the road and then drops back down to riverside hamlets before rising again over the next ridge. Route 6 overlooks were built in the 1930s to take advantage of spectacular views of the Susquehanna Valley from the ridge tops at Wyalusing Rocks and the French Azilum. Other improvements to US 6 consisted of straightening this roller-coaster road, leaving behind at least a dozen old road remnants that still wander back and forth across the main line of travel as forgotten back roads, dead ends, or abandoned weedy tracks.

West of Towanda, Route 6 traverses hilly farmland formed from soft, red shales. Harder sandstones and conglomerates hold up forested ridges to the north and south that pinch closer to the road with westward movement toward Wellsboro. The most significant US 6 reroute along this stretch occurred in 1941, when the road from Mansfield west to Whitneyville was rebuilt to carry the US 6 shield. Prior to that, US 6 followed the old Roosevelt Highway south from Mansfield to Covington and then west on what is now Pennsylvania Route 660.

With few alternative routes available, the alignment of US 6 across the mountainous Pennsylvania Wilds of Tioga and Potter Counties has been virtually unchanged since at least the 1940s and in place even the 1920s. At Wellsboro, Route 6 jogs north through the Marsh Creek glacial spillway that poured meltwater down Pine Creek to gouge out the Grand Canyon of Pennsylvania. Route 6 follows the upper part of Pine Creek from Ansonia through Galeton, angling northwest over a mountain of sandstone that crests at the top of Denton Hill.

Denton Hill, at 2,424 feet above sea level, is not only the highest point on Pennsylvania's Route 6, but is also part of the Eastern Continental Divide, which separates the water draining to the Atlantic Ocean by way of Pine Creek and the Susquehanna River from water draining to the Gulf of Mexico via the Allegheny, Ohio, and Mississippi Rivers. Denton Hill is just seven miles south of Triple Divide Hill, where the water also drains north to Lake Ontario and the St. Lawrence River. This is the only hill on the continent that drains into all three of these basins.

The road over Denton Hill was built in 1926. Prior to that, Roosevelt Highway was routed farther north through Brookland and Sweden to Sweden Valley, crossing the drainage divide 100 feet lower than Denton Hill. West of Denton Hill, Route 6 drops into the Allegheny River drainage basin and through the Potter County seat of Coudersport.

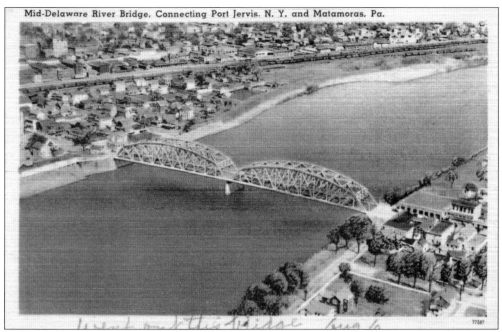

Mid-Delaware River Bridge, Connecting Port Jervis, N. Y. and Matamoras, Pa.

Route 6 crosses into Matamoras, Pennsylvania, from Port Jervis, New York, over the Mid-Delaware Bridge. Built in 1939, this 560-foot-long, two-span, steel truss bridge replaced the 1903 Barrett Bridge. Also seen in this vintage postcard is the main line of the Erie Railroad between New York City and Chicago, which crossed US 6 in Port Jervis and again in northwestern Pennsylvania.

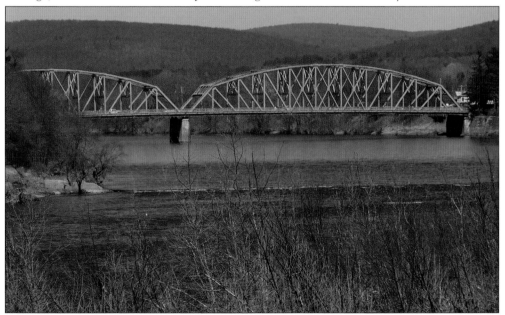

This recent view of the Mid-Delaware Bridge taken near Tri-State Monument shows New Jersey in the foreground, New York to the right, and Pennsylvania to the left. The background mountains are the eastern escarpment of the Pocono Plateau. Route 6 crosses the bridge and continues along the Delaware Valley to Milford, where it turns west to climb over the Poconos and into the Lackawaxen Valley at Hawley.

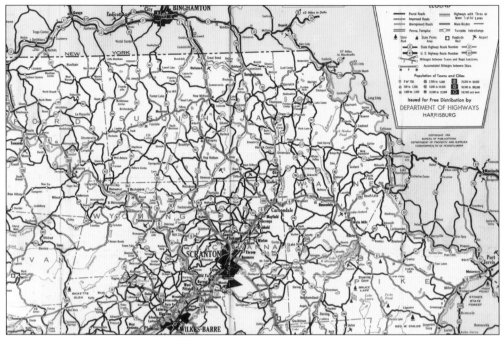

This 1952 Pennsylvania state highway map shows US 6 between Matamoras and Towanda. Route 6 followed the 1941 Scranton-Carbondale Superhighway, bypassing the old Route 6 Lackawanna Valley towns of Mayfield, Jermyn, Archbald, Blakely, and Dickson City. In 1952, US 6 also followed the Lake Winola route between Clark Summit and Tunkhannock rather than the new road through Factoryville; it would be relocated the following year. (Commonwealth of Pennsylvania Bureau of Publications, Department of Property and Supplies.)

When US 6 was marked across northern Pennsylvania in 1928, it followed this section of Old Milford Road between Matamoras and Milford, bypassed about 10 years later by the three-lane highway Route 6 follows today. In the 1890s, this was part of a popular bicycle route for New Yorkers who took the Erie Railroad to Port Jervis and bicycled down the River Road to Delaware Water Gap, where they caught the Lackawanna Railroad train back to New York City.

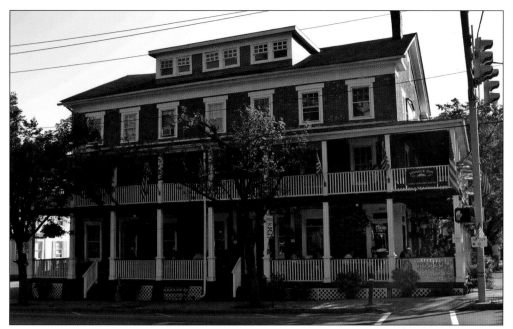

Samuel Dimmick, owner of the Milford-Owego stagecoach line, built Milford's original Dimmick Inn in 1828. His daughter Frances rebuilt the inn after an 1854 fire. With the Erie Railroad already in Port Jervis, Milford became the tourist gateway to the northern Poconos. With the loss of passenger train travel, Dimmick's was used for other businesses until its recent revival as hotel and restaurant.

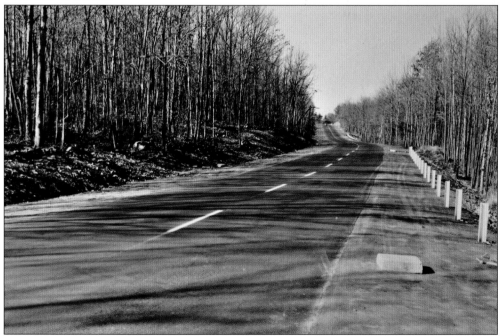

Route 6 was rebuilt over the Pocono Plateau in 1954 to handle increased tourist traffic after World War II. Freshly paved in this Pennsylvania Department of Highways image, this section of road through second-growth forest is east of Hawley. (PHMC.)

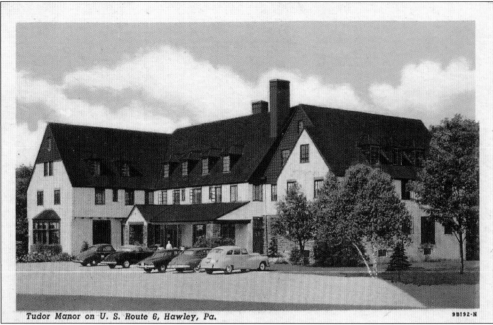

Tudor Manor on U. S. Route 6, Hawley, Pa.

Hawley businessmen started building Tudor Manor in 1927, anticipating a surge in tourists drawn to nearby Lake Wallenpaupack, which was completed the previous year. Construction halted by the stock market crash of 1929 was not completed until 1948, the year before this postcard was published. Still in business, Tudor Manor became the Settlers Inn in 1980.

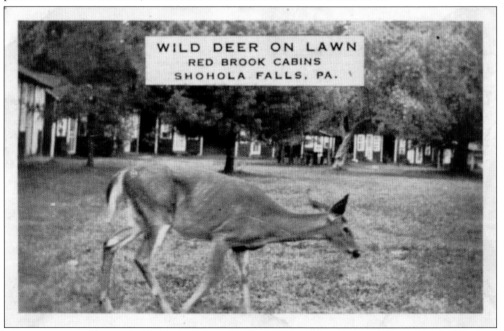

WILD DEER ON LAWN
RED BROOK CABINS
SHOHOLA FALLS, PA.

The midcentury Poconos had a resort for every budget. Red Brook Farm proprietors F. and J. Weidner advertised their cluster of "modern" cabins, café, and gas station on Route 6 near scenic Shohola Falls in the *Brooklyn Daily Eagle* during the late 1940s and early 1950s. This postcard redefines Weidner's modest cabin court as a wilderness retreat where wildlife strolls across the lawn.

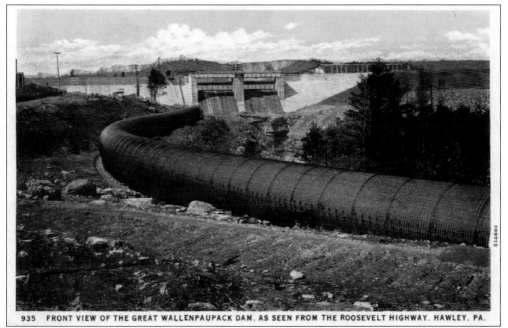

935 FRONT VIEW OF THE GREAT WALLENPAUPACK DAM, AS SEEN FROM THE ROOSEVELT HIGHWAY, HAWLEY, PA.

Pennsylvania Power & Light completed the dam that backed up Lake Wallenpaupack in 1926. Designed for both flood control and hydroelectricity, the lake also became the recreational focal point for the northern Poconos. The large pipe is a flume that still carries reservoir water to the power plant located three miles down the Lackawaxen River gorge. (Curt Teich postcard.)

This photograph was taken from Honesdale's Irving Cliff, named after Washington Irving's 1841 visit. This was the site of the 200-room Cliff House, which burned in 1889 weeks before its scheduled opening. Westbound Route 6 originally crossed the Lackawaxen River on Main Street (far bridge), turned left at the Wayne Hotel, and continued out Park Street towards Moosic Mountain (seen here on the horizon).

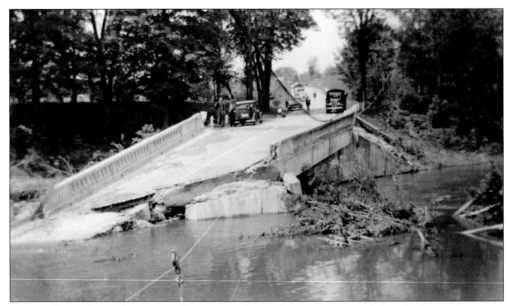

Many miles of Route 6 across northern Pennsylvania's stream-dissected Appalachian Plateau are vulnerable to flooding. A spring freshet in May 1942 destroyed 34 Wayne County bridges. This Route 6 bridge over the Lackawaxen River in Prompton and the Main Street Bridge that carried Route 6 over the Lackawaxen River in Honesdale were among those destroyed. (Wayne County Historical Society.)

Before the road was rebuilt wider, straighter, and flatter in the 1930s, Route 6 motorists between Honesdale and Carbondale meandered through the villages of Prompton and Waymart. Property owners planted tree colonnades along the berm to shade the road and frame their estates. A sense of the original road is retained along this section of Old State Road east of Prompton.

The Lackawanna Motor Club erected a coal monument as the appropriate centerpiece for the North Scranton Circle. Completed in 1941, the circle was the southern terminus for the Scranton-Carbondale Superhighway. It was also the northern gateway to Scranton, described on the monument as the "Anthracite Capital of the World." The North Scranton Expressway was built through the circle in 1964, and the coal monument was subsequently reconstructed at its current location in the median strip.

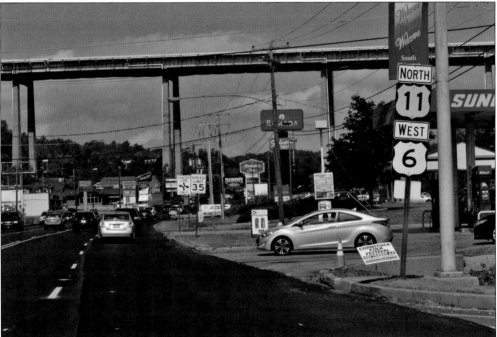

Route 6 joins US 11 at the North Scranton Circle and climbs out of the Lackawanna Valley through Leggetts Gap, entering the Clark Summit commercial strip of motorist services first stimulated by the completion of the Pennsylvania Turnpike's Northeast Extension (the high bridge) to US 6 in 1957. The Clark Summit strip intensified after 1963, when Interstate 81 was completed through the same interchange.

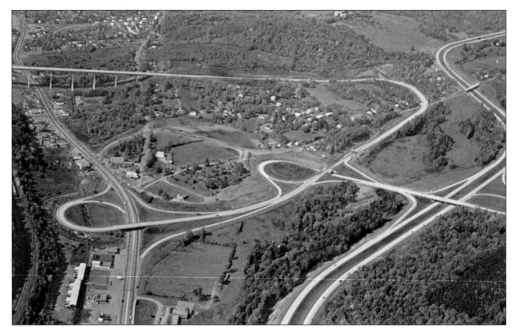

This mid-1960s postcard shows the three highways that intersect at the Clark Summit strip. The Pennsylvania Turnpike's Northeast Extension loops around to terminate at US 6 through a trumpet interchange. This design was favored because all traffic funnels through a single point that can easily be tollgated. A double set of trumpet interchanges connects the turnpike with Interstate 81. (Chambers Photographers.)

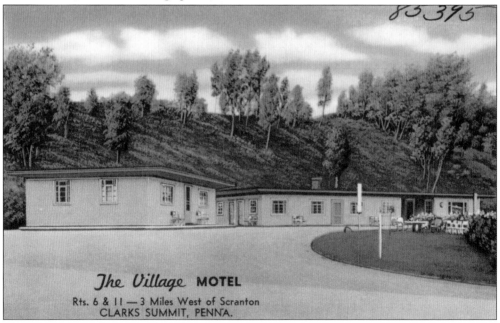

The modernist Village Motel, with its flat roofs and unadorned stucco sides in pastel green, opened on the Clark Summit strip around the time the turnpike arrived. It offered a few more amenities than the older roadside cabins and was a more convenient location than the in-town hotels. (Tichnor.)

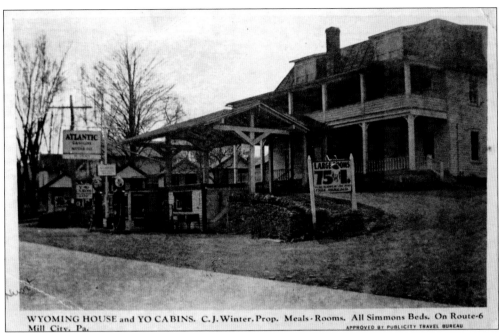

WYOMING HOUSE and YO CABINS. C. J. Winter. Prop. Meals - Rooms. All Simmons Beds. On Route-6
Mill City, Pa. APPROVED BY PUBLICITY TRAVEL BUREAU

Although the pumps, and cabins are gone, the building occupied by Wyoming House remains in Mill City along the old routing for US 6, which followed the pre-existing Roosevelt Highway through Lake Winola (now Pennsylvania Route 307) until 1953. Taking its name from the well-known Wyoming House in Scranton, C.J. Winter's Mill City establishment shows how small-town businesses adapted to the automobile once a major highway was routed past their doorsteps.

An abandoned relic from the early 20th century rusts along the slopes of Greenwood Hill just west of Lake Winola. This is where the original Route 6 (now Pennsylvania Route 307) dropped into the North Branch Susquehanna Valley and followed the scenic river for the next 45 miles to Towanda.

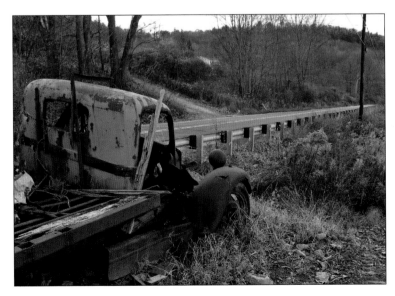

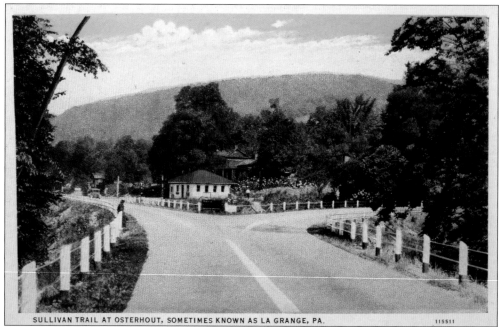

SULLIVAN TRAIL AT OSTERHOUT, SOMETIMES KNOWN AS LA GRANGE, PA. 115511

Osterhout was the wye in the road where the Roosevelt Highway (US 6) split from the Sullivan Trail. In this eastbound view beneath the brow of Greenwood Hill, US 6 goes left to Winola Lake and Scranton, while the Sullivan Trail, following the path of Gen. John Sullivan's 1779 expedition against the Iroquois, breaks right for Wilkes-Barre and Easton. Both auto trails followed the same path along the Susquehanna River from Osterhout northwest to Towanda. (Curt Teich postcard.)

Roadside services, like the Twin Maples Tourist Home, opened on the Lackawanna Trail near Factoryville soon after it was built over the top of the old Lackawanna Railroad right-of-way in 1916. Machine age innovations like the Bowser kerosene pump were adapted to pump gasoline with a dial display for more accurate measurement. Route 6 was constructed over this section of the Lackawanna Trail in 1953 after it was widened into a four-lane superhighway. (Wyoming County Historical Society.)

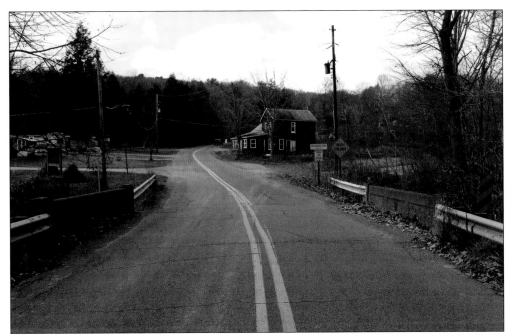

Just west of Tunkhannock, Route 6 followed Dark Hollow Road across the 1922 bridge (seen above) over Taques Creek until 1965, when a much wider and straighter three-lane bypass was built farther upstream. Dark Hollow Road retains the intimate characteristics Route 6 had at midcentury—following the contour of the land over narrow bridges and past houses built much closer to the road before the automobile reshaped the landscape. Modern Route 6, pictured at its intersection with Dark Hollow Road below, is a landscape reshaper built with deeper cuts and heavier fills, providing open vistas across the plateau surface.

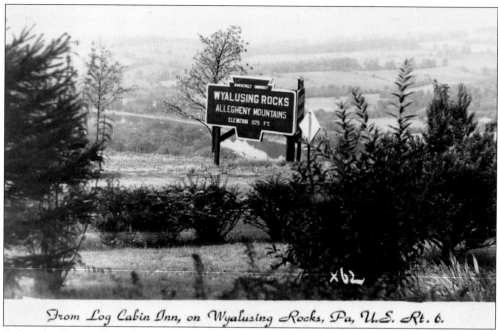

From Log Cabin Inn, on Wyalusing Rocks, Pa, U.S. Rt. 6.

Before the Roosevelt Highway was built over the plateau between Wyalusing and Towanda in 1925–1927, early motorists had to cross the Susquehanna River at Wyalusing and follow what is now Pennsylvania Route 187 to recross the river at Wysox rather than negotiate the unimproved Old Stagecoach Road through Rummerfield and Standing Stone. Two overlooks were built on the new Roosevelt Highway in the 1930s, providing spectacular views of the Susquehanna River valley and the Endless Mountains. The overlook at Wyalusing Rocks (seen above) is just north of Wyalusing across from what was once a collection of tourist cabins known as the Log Cabin Inn. Romanticized Indians have been associated with Wyalusing Rocks ever since 1929, when a rock monument was erected by the Rainbow Club of Wyalusing defining this 500-foot cliff as an Indian lookout.

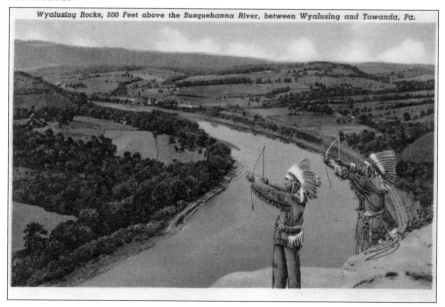

Wyalusing Rocks, 500 Feet above the Susquehanna River, between Wyalusing and Towanda, Pa.

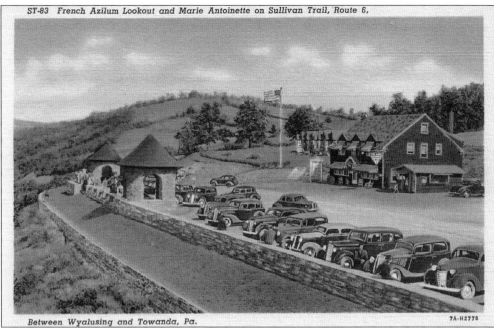

ST-83 French Azilum Lookout and Marie Antoinette on Sullivan Trail, Route 6,

Between Wyalusing and Towanda, Pa. 7A-H2778

Bradford County's Marie Antoinette Overlook on Rummerfield Mountain is a cliff-top vista of the Susquehanna River valley where French Royalists set up a refuge in 1793 for nobles escaping the French Revolution. Queen Marie Antoinette was executed before getting to French Azilum, but other nobles created a community here until pardoned by Napoleon Bonaparte in 1803. The overlook, its French-styled turrets, the Marie Antoinette Inn, and a string of cabins, all still standing, were built during the Great Depression. The Pennsylvania Historical Commission erected the stone "French Asylum" marker at the Marie Antoinette Overlook in 1930, suggesting the date when it was completed. View scopes provided tourists with closer looks at the site on the floodplain across the Susquehanna River. (Above, Curt Teich postcard.)

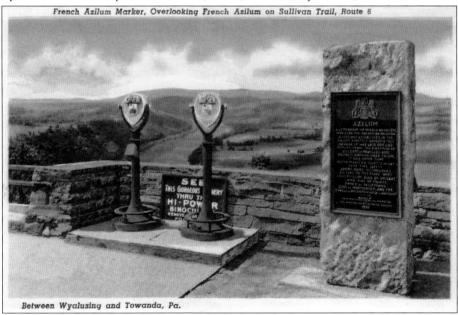

French Azilum Marker, Overlooking French Azilum on Sullivan Trail, Route 6

Between Wyalusing and Towanda, Pa.

37

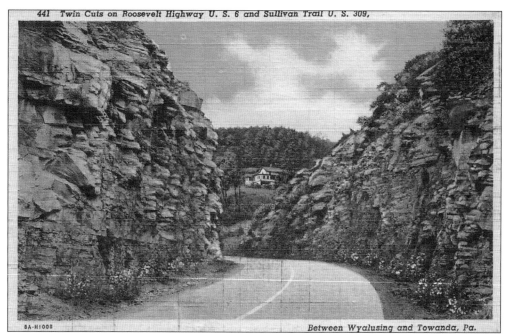

8A-H1008 *Between Wyalusing and Towanda, Pa.*

The Roosevelt Highway arced around the head of two hollows north and south of the Marie Antoinette Overlook until bypassed in the 1970s by the current Route 6. The remnant south of the overlook was part of the Old Stagecoach Road. To the north, two pieces of abandoned Route 6 each contain one of the Twin Cuts blasted through the rock of Rummerfield Mountain in 1925. The postcard above shows the impressive east Twin Cut in a view looking westbound. The recent photograph below shows the same cut in a view looking the other way. When compared to the canyon dug for US 6 in the 1970s (left), the old Twin Cut (right) is barely noticeable. (Above, Curt Teich.)

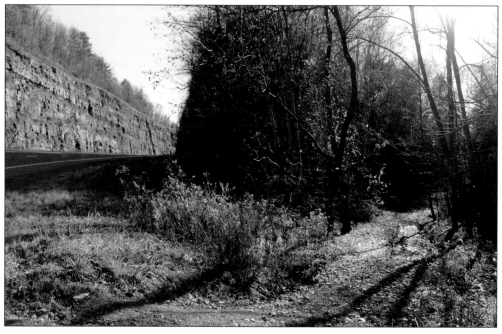

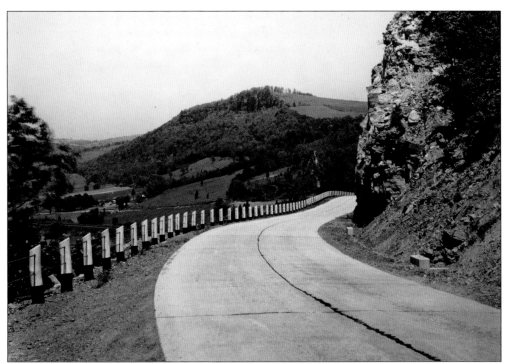

Standing Stone Narrows is the steep-sided cliff carved by an outward eroding meander of the Susquehanna River at Red Rock Mountain just east of Wysox. The 1928 Pennsylvania Department of Highways westbound view above shows the newly opened Roosevelt Highway occupying a bench cut into the slope at Standing Stone Narrows. An impressive engineering feat worthy of a postcard in its day, the road is dangerously narrow with minimal shoulders and inadequate guardrails compared to the recent photograph below. This is the same slope in a view taken from the base of Red Rock Mountain and looking up a much larger bench cut for a wider three-lane US 6 built in the 1970s. (Above, PHMC.)

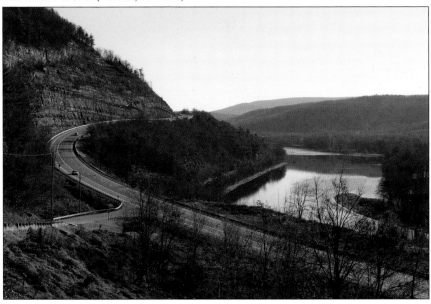

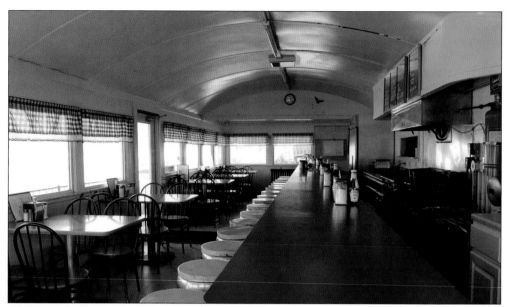

Charles Pipher opened Pipher's Diner on Wysox's Route 6 commercial strip in 1936. A year later, it was sold to Daniel Aquilio, whose son Lou now runs it. Remodeled and expanded in the 1960s, the old Pipher's Diner still exists, as evidenced by the barrel-roof ceiling that can be seen on the inside. Famous visitors to Pipher's include Bette Davis and the Lone Ranger, Clayton Moore.

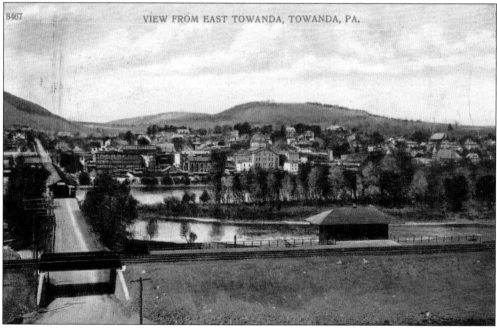

This early-20th-century postcard shows Towanda and the domed Bradford County Courthouse across the Susquehanna River. The Roosevelt Highway was routed this way in 1924, and US 6 in 1928. By then, the covered bridge had been replaced by the four-span through-truss County Bridge, which was dismantled when the Veterans Memorial Bridge opened in 1986. The old Route 6 remnant through the Lehigh Valley Railroad underpass still exists, as does the Bridge Street approach to the old bridge in downtown Towanda.

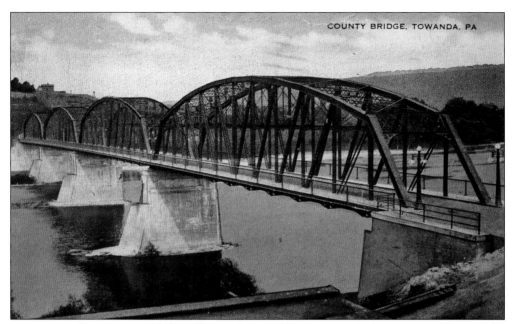

Anticipating heavier automobile traffic on what would become US 6, the County Bridge over the North Branch Susquehanna River at Towanda replaced the old 1838 covered bridge. The East Towanda approach abandoned the short, steep hill on East Street for an S-curve around the hill that was bypassed when the Veterans Memorial Bridge opened farther downstream.

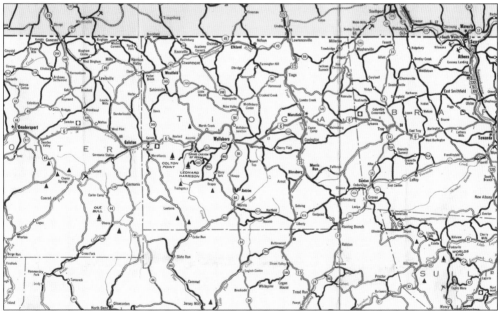

This 1952 Pennsylvania state highway map shows Route 6 between Towanda and Coudersport. Still in the Susquehanna drainage basin, this is the western part of the Endless Mountains, a name referring to that section of the Appalachian Plateau between the Poconos and the Allegheny River drainage divide in Potter County. Pennsylvania maps have referred to this region as the Endless Mountains since at least 1756. (Commonwealth of Pennsylvania Bureau of Publications, Department of Property and Supplies.)

West from Towanda, Route 6 follows Sugar Creek Valley upstream past Burlington, West Burlington, and the Hilton Cemetery, a rural graveyard surrounded by rolling farmland. Small, rural cemeteries along Route 6 memorialize the families of the first farmers from New York and New England who settled the Sugar Creek Valley.

After the Pennsylvania Department of Highways designated which roads would become the Roosevelt Highway in 1924, they were improved with all-weather pavement, new bridges, and better alignments. The road across Bradford and Tioga Counties was done between 1924 and 1928, including this piece east of Mansfield. Modern US 6 was extended from Brewster, New York, to Erie in 1928 because of these improvements to the Roosevelt Highway. (PHMC.)

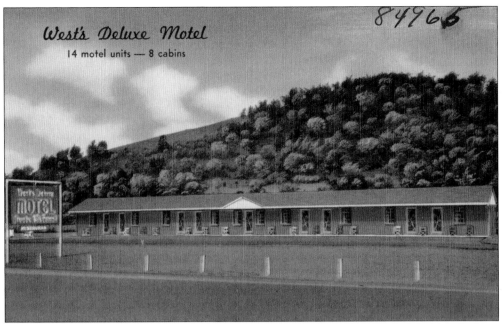

West's Deluxe Motel south of Mansfield advertised "14 motel units – 8 cabins," representing a transition of facilities after World War II when modern motel strips were added to prewar cabin courts. Afterward, most motels like West's abandoned their cabins. West's Motel continues to operate on Pennsylvania Route 660 in Covington, which was part of Route 6 until 1941, when it was relocated to the new road west from Mansfield to Whitneyville. (Tichnor.)

Route 6 was originally routed south from Mansfield (over old US 15) to Covington, then west to Whitneyville (over what is now Pennsylvania Route 660). When the new Route 6 was constructed between Whitneyville and Mansfield in 1940 and 1941, this remnant of old Route 6 was left behind as a country lane just west of the US 6–Pennsylvania Route 660 intersection at Whitneyville.

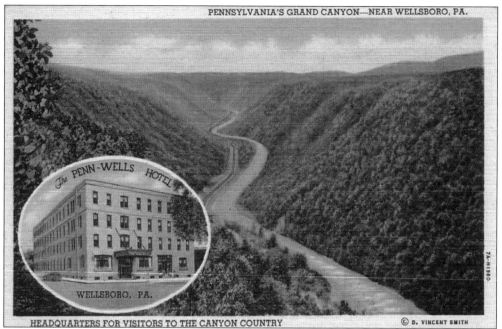

The PENN-WELLS HOTEL

WELLSBORO, PA.

HEADQUARTERS FOR VISITORS TO THE CANYON COUNTRY

© D. VINCENT SMITH

The Grand Canyon of Pennsylvania (Pine Creek Gorge) is the centerpiece in a region of deep forests and high, dissected plateaus. Route 6 skirts just north of the gorge, west of Wellsboro. Coupled with the canyon on this postcard image, the Penn-Wells Hotel was built in 1869 and has been the flagship hotel in downtown Wellsboro ever since it was renovated and reopened under that name in 1926. (Curt Teich postcard.)

This eastbound view of Mount Tom catching the last light of day also shows Route 6 approaching the village of Ansonia. Mount Tom deflects Pine Creek southward into the Grand Canyon of Pennsylvania, whereas Route 6 is deflected northward up Marsh Creek valley and around Mount Tom to Wellsboro.

44

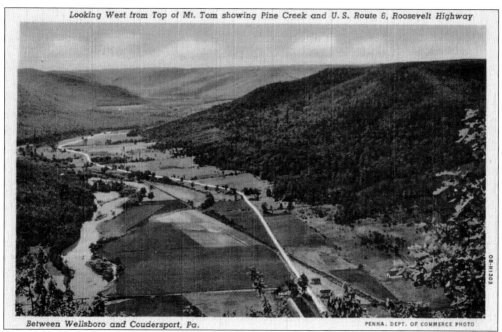

Between Wellsboro and Coudersport, Pa.

PENNA. DEPT. OF COMMERCE PHOTO

Route 6 West from Mount Tom, captured in this 1940 postcard, tracks up Pine Creek valley toward the high, forested plateau on the drainage divide between the Susquehanna and Allegheny Rivers. It runs with what was then a branch of the Baltimore & Ohio Railroad built by the Buffalo & Susquehanna Railroad in the 1890s to extract lumber and coal from northern Pennsylvania. (Curt Teich postcard.)

Several Route 6 cabin courts, like JT's shown here, survive in the Galeton area. Route 6 alignment in the rugged terrain of the Pennsylvania Wilds has changed little over the decades, so the relationship between these older lodgings and the road has stayed the same. Built for Route 6 travelers, the remaining cabin courts also cater to seasonal vacationers, hunters, fishermen, and, more recently, transient workers in the Marcelus shale gas fields.

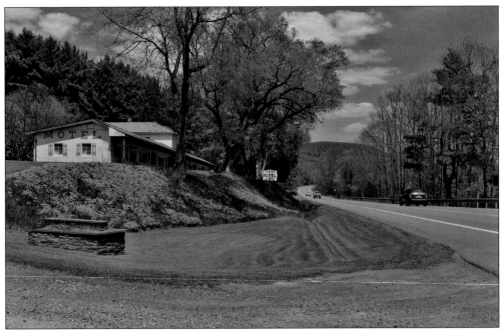

The sense of Route 6 at midcentury is retained east of Galeton, where the road threads through the narrow Pine Creek valley past the Nob Hill Motel. It was opened and operated by the Owen family in the early 1950s and then operated by subsequent generations, including the Sparber and Piaquadio families, who continue to manage this business.

The Potter County Visitors Association slogan describes the county as "Untouched. Unspoiled. Untamed." An older slogan that has been around since at least the 1960s, "God's Country," is stated on county line welcome signs. Potter County is the rooftop of Pennsylvania's Route 6, containing the highest elevations on a forested plateau shared by both loggers and tourists.

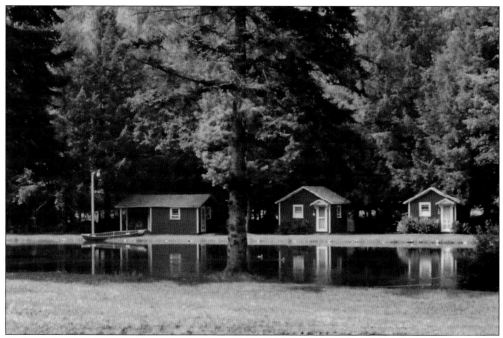

Idyllic cabins in a mountainous, pine tree setting are quintessential Potter County. Located on the east slope of Denton Hill west of Galeton, Nine Mile Motel is another Route 6 cabin court built in conjunction with a gas station during the 1930s. Over the decades, the cabin court shifted its focus away from overnight guests to the summer vacation and seasonal sportsman trade, eliminating the gas station and relocating the cabins behind a man-made pond.

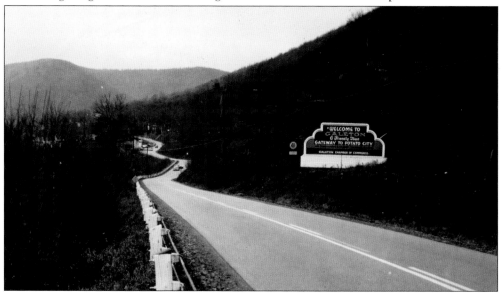

The 1950 chamber of commerce sign on Route 6 defines Galeton as the "Gateway to Potato City and Pennsylvania's Black Forest." The "Black Forest" label redefined the second-growth state forests, regenerated after the clear-cut logging of the 19th century as a "Sportmen's Paradise." Opened at the crest of Denton Hill in 1949, Potato City became the largest and most well-known tourist resort in the Black Forest. (PHMC.)

Galeton's renowned Route 6 roadside complex is the Ox-Yoke Inn, assembled by Franklin Milliron, who started with a restaurant–gas station and a few cabins around 1935. In the late 1950s, he opened the adjacent Galeton Custard Stand and added this L-shaped, Colonial Revival motel on the floodplain behind the restaurant defined on postcards as "ultra-modern." Frank's restaurant slogan, "Where every meal is a pleasant memory," faded after his death in 1971.

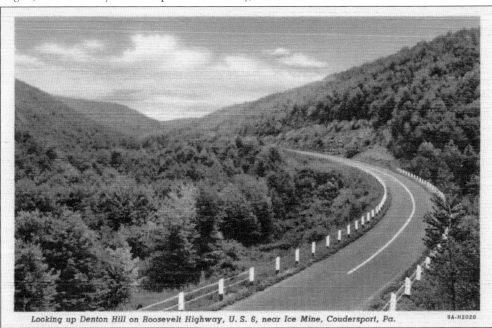

Looking up Denton Hill on Roosevelt Highway, U. S. 6, near Ice Mine, Coudersport, Pa. 9A-H2020

The Pennsylvania Department of Highways built Roosevelt Highway up Ninemile Run and over Denton Hill in 1925, constructing what it called "the Big Fill" on the curve depicted in this 1939 postcard. Before then, westbound travelers followed the road paralleling the Buffalo & Susquehanna Railroad to Brookland, and then crossed the Susquehanna-Allegheny drainage divide over Sweden Hill. The Big Fill has since been bypassed by an even bigger fill built for the current Route 6. (Curt Teich postcard.)

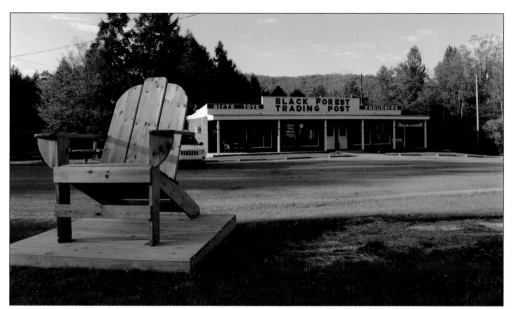

Attractions in Potter County include the Pennsylvania Lumber Museum, just west of Galeton, and the Black Forest Trading Post and Deer Park, with its herd of fallow deer in Walton. The Deer Park dates back to the 1950s, when places to feed penned deer were common along the roadside. It is at the intersection of US 6, Pennsylvania Route 449, and Telescope Road, a bypassed remnant of 1920s-era Route 6.

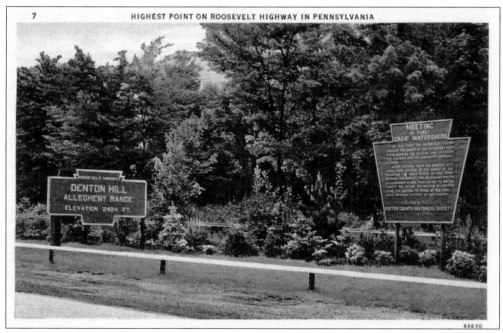

At 2,424 feet above sea level, the crest of Denton Hill is the highest point of Pennsylvania's Highway 6. The Eastern Continental Divide drainage between the Susquehanna and Allegheny watersheds is explained on the "Meeting of the Great Watersheds" marker recorded in this 1936 postcard. It also describes the third watershed just a few miles to the north, where the water drains down the Genesee River to Lake Ontario. (Curt Teich postcard.)

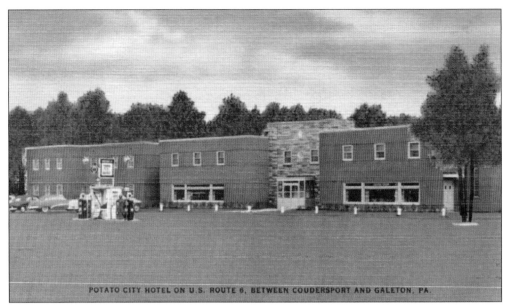

POTATO CITY HOTEL ON U.S. ROUTE 6, BETWEEN COUDERSPORT AND GALETON, PA.

The Pennsylvania Potato Growers built Potato City at the crest of Denton Hill as a meeting place for their association in 1949. The Route 6 site was part of their Camp Potato, a research and development facility established in 1936 when many upland farmers in Potter County grew potatoes. The hotel was subsequently sold off to become a private mountain resort that, for a time, maintained gas pumps.

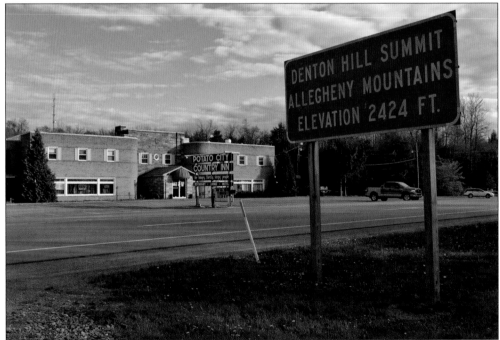

The Potato City Country Inn still operates as a mountain resort, which offers seasonal recreation such as hiking, biking, golfing, ATV trails, snowmobiling, and skiing. The hotel itself retains the streamlined corners, unornamented surfaces, and glass block detailing that defined modernism in the 1940s.

Three

Route 6 Road Trip West

Coudersport, the Potter County seat, is the first large town west of the Allegheny-Susquehanna drainage divide on Denton Hill. This far up, the Allegheny River is a small headwater stream crossed by Route 6 three times as it meanders through town. West from Coudersport, US 6 follows the banks of the Allegheny as far west as Port Allegany, where the river starts its great sweeping arc northward into New York before flowing south to rejoin Route 6 in Warren. The first generation Route 6/Roosevelt Highway followed the Allegheny River beyond Port Allegany to Larabee (current Pennsylvania Route 155), where it turned south up Potato Creek (now Pennsylvania Route 446) through Farmers Valley to Smethport. This circuitous Farmers Valley loop was a longer road to Smethport but a much better one, with easier grades than the narrow, twisting lane that went west from Port Allegany over Bush Hill. The old Bush Hill road, once State Highway 59, was itself an improvement over the original East-West Road, which still exists as a Jeep trail. The third and final Bush Hill road was built in the mid-1930s as a shorter, straighter highway with deeper cuts and heavier fills that captured the US 6 shield from the Farmers Valley Route in 1941.

West of Smethport, Route 6 follows Marvin Creek Valley up to "the Big Level," a high piece of Allegheny Plateau second in elevation only to Denton Hill. Oil and gas wells pockmark the Big Level as part of the modern world's oldest developed oil field, producing since Edwin Drake's 1859 strike near Titusville. Route 6 between Mount Jewett and Kane was rebuilt in the 1930s to eliminate 11 grade crossings of a paralleling Baltimore & Ohio branch line that has since been abandoned. Remnants of the old alignment survive, including two sections near the village of Kanesholm that retain the brick surface the road was given when it was first hard-surfaced for automobiles in the 1920s. Route 6 passes through the Allegheny National Forest between Kane and Warren while gradually descending the west slope of the Big Level.

Although a new US 6 bypass opened around Warren in 1987, the old road was routed across the Glade Bridge, past the United oil refinery, and through downtown Warren on Pennsylvania Avenue. Farther west at Irvine, the Allegheny River bends south as US 6 turns up Brokenstraw Creek over the first limited-access expressway built for Pennsylvania's Route 6. Opened in 1969, the three-mile long Irvine Bypass was influenced by the new standards set by the national Interstate Highway System, then under construction. West from Warren, the hills along Route 6 lower and recede. Forests fade to be replaced by rolling farmland that flattens out to become more Midwest-like with every mile approaching the Ohio border.

Across the Erie County line, US 6 enters Union City, where the original route turned north and west through Waterford to a terminus in Erie. When US 6 was marked west to Greeley, Colorado, in 1931, the road split at Union City. The old road to Erie became US 6N (now Pennsylvania

Route 97), and westbound Route 6 was marked through Mill Village to join the Perry Highway (US 19) south to Meadville. In 1935, US 6N was also relocated away from Erie to split from US 6 at the Perry Highway intersection, then west through Edinboro and Albion to Conneaut, Ohio, on Lake Erie. Now, the Route 6N shields end at US 20 in West Springfield. Westbound Route 6 runs with US 19 south along the banks of French Creek, crossing and recrossing that stream six times over truss bridges built in the 1930s to replace the narrow through-truss wagon and electric interurban bridges the road previously used.

At midcentury, Meadville was a thriving little city of 18,000 people, in which the through traffic on Route 6/19 was actively being shunted away from downtown streets and onto four-lane highways. A new viaduct opened over French Creek and the Erie Railroad in 1954, connecting with a four-lane highway that bypassed Kerrtown. The four-lane was extended west to Conneaut Lake by 1961. Route 6 through Meadville was rerouted from Baldwin Street and Park Avenue to the dual-lane French Creek Parkway in 1974.

The four-lane ends at Conneaut Lake, the largest natural lake in Pennsylvania (a gift of the glacier). By midcentury, Conneaut Lake was a watery playground of second homes and boats, with an amusement park at its north end that was still serviced by excursion trains as late as 1969. Beyond Conneaut Lake, Route 6 continues west as a two-lane country road rounding the north shore of Pymatuning Reservoir before crossing the Ohio border and stretching off to the horizon.

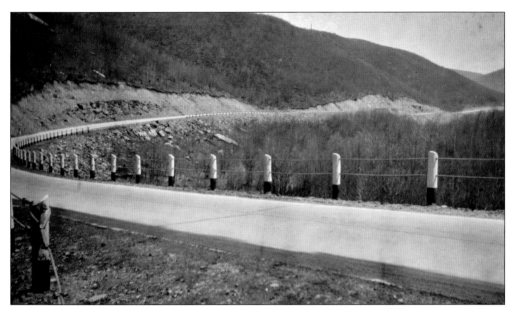

This view is looking east down Denton Hill in 1928 after the Roosevelt Highway was completed through the headwaters hollow of Ninemile Run. Rock from hillside cuts was used to make the bench for the road and the Big Fill (foreground curve) across the mouth of Big Fill Hollow. On the other side of Denton Hill, Route 6 follows Trout Run west through Sweden Valley and into the Allegheny River basin. (PHMC.)

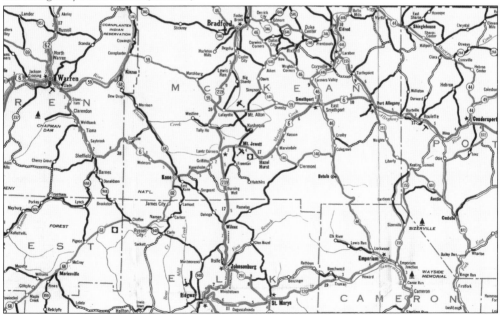

Route 6 across the Allegheny Plateau from Coudersport to Warren in 1952 was nearly identical to what it is today. The original routing followed what is now Pennsylvania Route 155 west from Port Allegany to Larabee and Pennsylvania Routes 446 and 46 through Farmers Valley to Smethport. The alignment of the 1807 East-West Road approximated US 6 east of Smethport, but was closer to Pennsylvania Route 59 between Smethport and Warren. (Commonwealth of Pennsylvania Bureau of Publications, Department of Property and Supplies.)

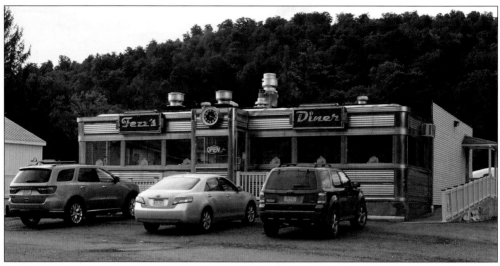

Fezz's Diner serves Route 6 travelers and locals in the Sweden Valley–Coudersport area. It is a 1954 Silk City diner built in Paterson, New Jersey, and then shipped to Bethlehem, Pennsylvania, where it last operated as the Community Diner before being relocated to Sweden Valley in 2002. Diners like Fezz's are the epitome of midcentury modernity; it was built in a factory with eye-catching materials like stainless steel and colorful porcelain enamel panels and trucked to the roadside as a turnkey operation.

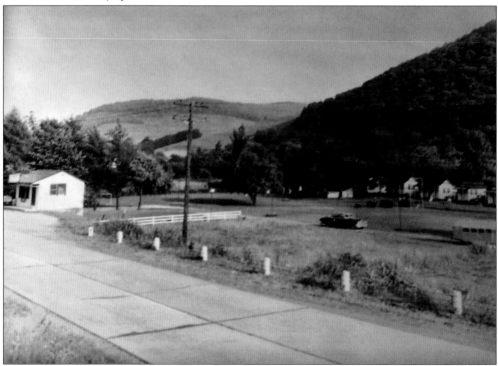

The Lindy Motel is a vintage Route 6 cabin court built in 1932 with a kitchen facility and a common bathhouse east of Coudersport. It was named for aviator Charles Lindbergh five years after his historic transatlantic flight and six years after the Roosevelt Highway was completed over Denton Hill. It was later run by Harry and Patricia Knauer. (Dan and Karen Parson.)

By 2016, Dan and Karen Parson owned the Lindy Motel. The 10 cabins have been modernized but little else has changed, and the site retains the appearance of an early auto roadside. Seasonal tourists and outdoorsmen have replaced long-distance transients traveling Route 6. The Lindy Motel sits on five acres between US 6 and Mill Creek, a wild trout stream.

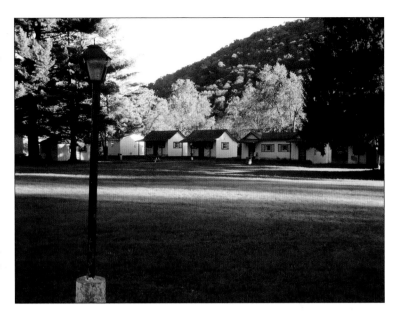

The recently reopened Coudersport Ice Mine is just south of US 6 in Sweden Valley. Originally dug as a silver prospecting hole in 1894, the Ice Mine had the curious ability to form icicles at the approach of summer that would melt with the approach of fall. The water freezes due to cold, winter air stored in the rock rubble of the mountain slope during the winter draining through the hole in the summer. First opened as a tourist attraction in 1901, it was intensively advertised as the most famous natural attraction on Pennsylvania's Route 6 until dwindling customers forced its closure in 1990. (Curt Teich postcard.)

The view east toward Coudersport from St. Eulalias Cemetery shows US 6 threading the narrow valley carved by the Allegheny River between Dutchman Hill (right) and Niles Hill (out of view to the left). The river provided a flat-bottomed path through the rugged terrain of the Allegheny Plateau that Route 6 follows from Coudersport to Port Allegany.

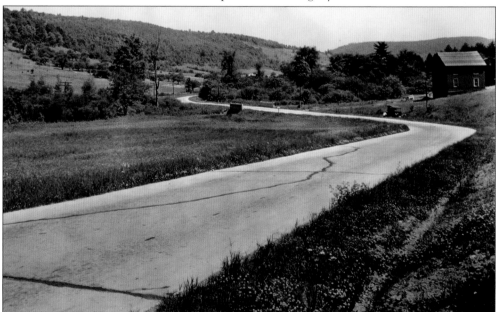

Until 1941, US 6 followed the Farmers Valley route along the Allegheny River from Port Allegany to Larabee (now Pennsylvania Route 155) and then up Potato Creek through Farmers Valley to Smethport (now Pennsylvania Route 446). This was a longer, lower-grade route than the more direct road over Bush Hill and much easier for early automobiles like the one abandoned here along the Roosevelt Highway. (PHMC.)

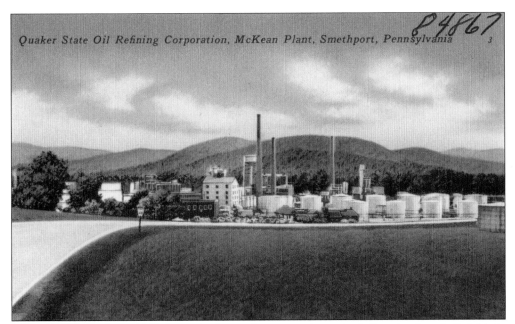

The pre-1941 westbound US 6 travelers' introduction to the nation's first developed oil fields in northwestern Pennsylvania was the Quaker State oil refinery at Farmers Valley, built in 1923 for McKean County producers and bought by Quaker State in 1929. Route 6 was relocated away from Farmers Valley 75 years ago, but the refinery is still there, now producing waxes for International Group. (Tichnor.)

Motorists on the Farmers Valley Route got from Port Allegany to Smethport in 18 miles, whereas those following State Route 59 over Bush Hill got there in 9 miles—but no sooner due to the winding, poorly paved mountainous road. A new road was built over Bush Hill in the mid-1930s that captured the US 6 shield in 1941. It is depicted on this 1950s postcard ascending Ostrander Hollow through a landscape more farmed than forested in comparison to today.

Route 6 crosses old State Route 59, now known as Old Bush Mill Road, in Ostrander Hollow, west of Port Allegany. Both roads continue west, up and over a remnant of the Allegheny Plateau between the Allegheny River and Potato Creek. Route 6 crests through several road cuts, whereas Old Bush Mill Road follows a more circuitous route over the top, connecting with the unpaved Baker Road.

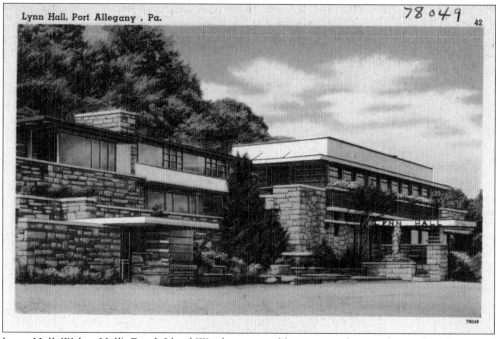

Lynn Hall, Walter Hall's Frank Lloyd Wright–inspired house, stands near the Bush Hill crest of Route 6 west of Port Allegany. Its early modern stonework, terraces, and Prairie-style horizontality predate Wright's Fallingwater. After largely completing Lynn Hall by 1936, Hall was hired as the builder at Fallingwater. Lynn Hall operated as an elegant, contemporary restaurant until 1953 and even had gas pumps for a while but has since slipped into obscurity, where it awaits resurrection. (Tichnor.)

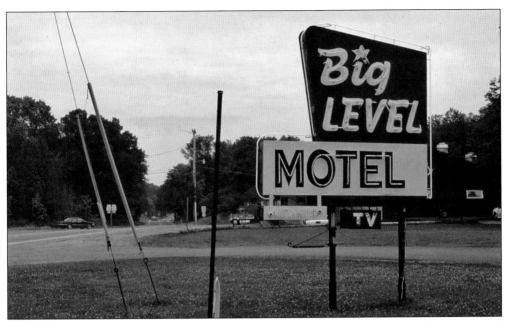

Now the Getaway Motel and Conference Center, the old Big Level Motel in Lantz Corners carried the name of the westernmost piece of high plateau on Route 6 located between Mount Jewett and Kane. The road twists across the Big Level hugging the drainage divide between Kinzua Creek and the Clarion River. For decades, the now lost metal box sign was a splash of midcentury neon on a remote stretch of road.

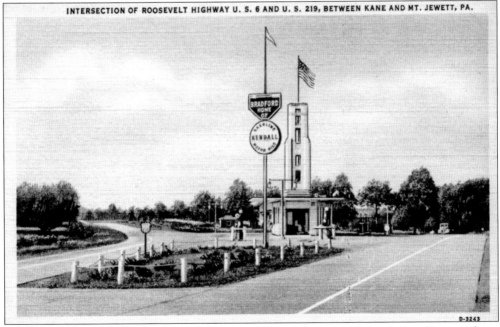

The Buffalo-Pittsburgh Highway, US 219, originally intersected Highway 6 in Kane and ran concurrent with it to this split at Lantz Corners occupied by a pylon-topped Kendall gas station in the 1930s. Kendall oil was originally refined just north in Bradford, stimulated by an oil strike made in 1875. (Curt Teich postcard.)

A new alignment was constructed for US 219 in the early 1950s that replaced the Kane routing with a more direct road north from Wilcox to cross US 6 at Lantz Corners, enhancing the little crossroads' role as the gas, food, and lodging stop of the Big Level. The Big Level Motel was subsequently built here, as were gift shops catering to tourists drawn to nearby Allegheny National Forest. The old Kendall station, closed and without its pylon, still stands at the split.

An abandoned early gas station stands between two generations of US 6 just east of Ludlow. Wildcat Road (behind the building) and Wetmore Road were part of the old state route east to Kane. The new road was constructed for US 6 around 1929, and the gas station was built soon after. This was also when the town of Ludlow was constructing Wildcat Park across the road. Nearly the entire distance between Kane and Warren—the west slope of the Big Level—was ensconced in the Allegheny National Forest in 1923.

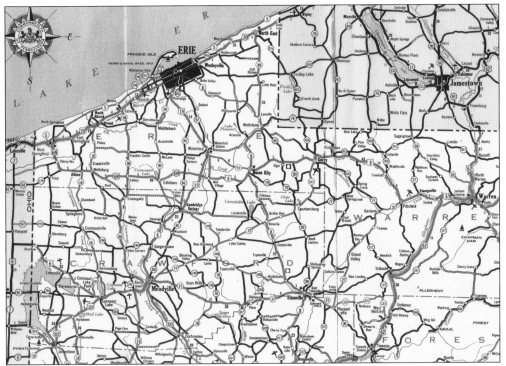

Route 6 across northwestern Pennsylvania today was largely established by the time this 1952 Pennsylvania state highway map was printed. Yet to be built were the 1973 Meadville bypass, the north Corry bypass, the 1971 Youngsville-Irvine bypass, and the 1987 Warren bypass. The 1928 US 6 route to Erie followed what on this map is marked as Pennsylvania Route 97 west from Union City. (Commonwealth of Pennsylvania Bureau of Publications, Department of Property and Supplies.)

Westbound Route 6 returns to the banks of the Allegheny River at Warren and follows the river to Irvine, creating a transportation corridor with the paralleling railroad, which was built as the Pennsylvania Railroad's Philadelphia & Erie Line in 1864. Route 6 and the old Pennsylvania Railroad are corridor companions from Kane to Union City.

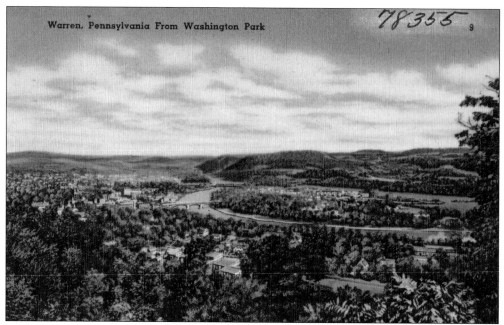

This panoramic overview of Warren from Washington Park shows the topographic break between the higher parts of the Allegheny Plateau to the east (that includes the Allegheny National Forest) and the lower elevations of the glaciated plateau Route 6 crosses to the west. (Tichnor.)

Route 6 inherited Warren's Glade Bridge across the Allegheny River from the Warren & Sheffield Street Railway, which built the original, four-span, through-truss, double-deck bridge in 1907 with the streetcar line on top and a roadway beneath. The line was abandoned in 1928, but the trolley track superstructure was still on the trusses when this Pennsylvania Department of Highways photograph was taken in 1933. (PHMC.)

62

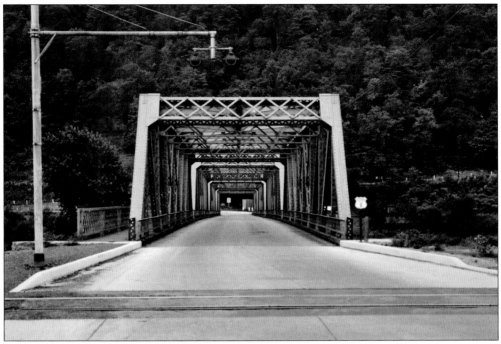

Four generations of bridges spanned the Allegheny River between the villages of Rogertown and Glade (now part of Warren), and the middle two were used by Route 6. The Pennsylvania Department of Highways replaced the 1907 Warren & Sheffield Street Railway bridge with this four-span through-truss in 1934. The street railway bridge had replaced a Howe truss built in 1881, and the Department of Highways' bridge was itself replaced by the current steel-beam bridge in 1987. The newest bridge, however, was not built for US 6, but in conjunction with the Route 6 bypass through Crescent Park, which crossed the Allegheny River farther west over an expressway completed in 1976. (Both, PHMC.)

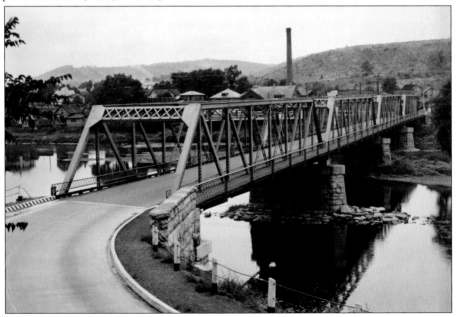

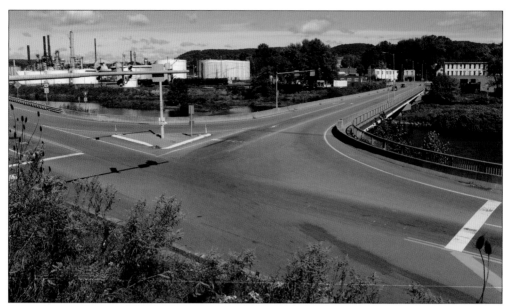

Since the completion of the Warren Bypass through Crescent Park in 1987, Route 6 has stayed to the south side of the Allegheny River at the Glade Bridge. Across the river, the United Refining Company has operated in Warren since 1902 and now supplies gasoline to 300 Kwik Fill/Red Apple convenience stores in Pennsylvania, western New York, and eastern Ohio.

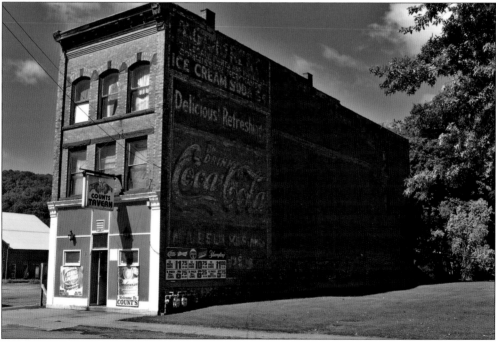

The Coca-Cola wall sign on Counts Tavern faces Pennsylvania Avenue (old US 6) in Warren's West End, a working-class neighborhood surrounding the Struthers-Wells plant that, until 1993, made tanks and equipment for the oil industry. Counts was originally built as a restaurant next to the Revere Hotel, which was next to the Pennsylvania Railroad station and around the block from St. Joseph's Catholic Church and School. All but Counts have been demolished.

Route 6 westbound is pictured here heading toward Columbus at the edge of Benson Swamp, where the hills get lower and the terrain starts to level out compared to places farther east. An abandoned canopy gas station from the 1930s still stands at the intersection with Baccus Corners Road.

The old Pennsylvania Railroad's Philadelphia & Erie Line cuts eastward across the Union City intersection, where the 1928 US 6 and the original Roosevelt Highway turned north (left) to Erie. The post-1931 US 6 turned south (right) on Main Street through downtown Union City and on to Greeley, Colorado. Route 6 only held that western terminus until 1937, when it was extended to Long Beach, California, becoming America's longest transcontinental highway.

In 1931, US 6 was routed west from Union City through Mill Village, then south down the French Creek Valley over the Lakes-to-Sea Highway (another Pennsylvania Department of Highways auto trail designated in 1924) to Meadville, where the Lakes-to-Sea Highway turned east. As it does now, US 6 crossed this 1906 through-truss spanning French Creek with US 19 to pass through the old mineral water resort town of Cambridge Springs.

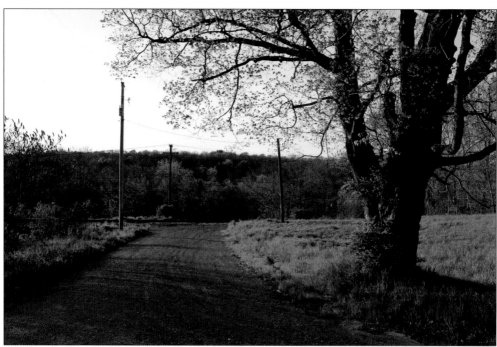

Some of the oldest roadway remnants and improvements west of Union City predate the 6 shield. The original state route north from Saegertown followed Bockman Hollow Road, crossing and then recrossing the Erie Railroad tracks here to go over French Creek on the Broadford Bridge. When the route was designated part of the Lakes-to-Sea Highway, a new road was built on the west side of the Erie Railroad, eliminating both grade crossings.

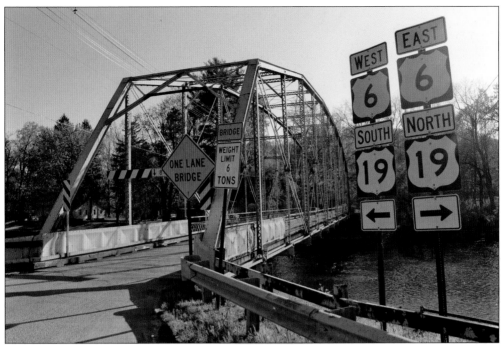

The oldest Route 6 through-truss standing in Pennsylvania spans French Creek at Saegertown. Built in 1900 by the Youngstown Bridge Company of Youngstown, Ohio, the span and the west bank roadway remnant now known as Jordan Drive (right) supported US 6 traffic for only a few years in the 1930s before a new through-truss was completed for US 6/19 farther downstream.

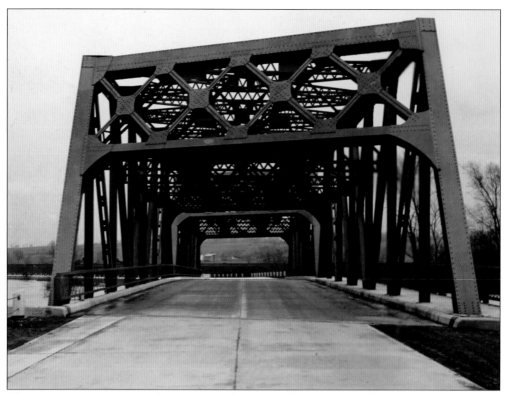

The greatest concentration of Route 6 truss bridges on the entire transcontinental highway is in Crawford County, where six still span French Creek in the 15 miles between Cambridge Springs and Meadville. The older truss bridges at Cambridge Springs (1906) and Saegertown (1900, on Jordan Drive) were inherited by US 6, but the Pennsylvania Department of Highways built the other four as improvements to Routes 6 and 19 using a standard Pratt design, so they all look similar. Like timeless bridge siblings, this 1937 photograph above of the 1936 Saegertown bridge bears a striking resemblance to a recent image of the 1934 Venango bridge seen below. Another two-span through-truss like these was built just north of Meadville in 1937, and lastly, the Mercer Street Bridge in Meadville was completed in 1932. (Above, PHMC.)

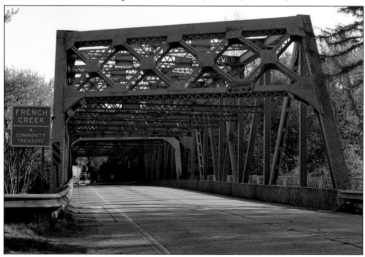

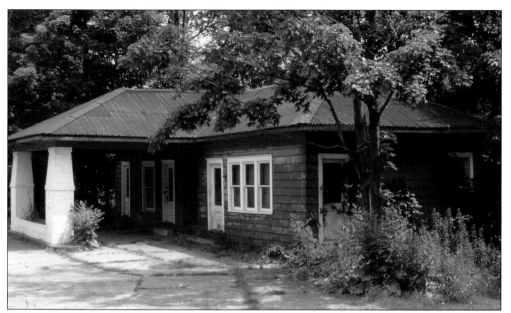

This now demolished canopy gas station served Route 6 traffic south of Venango. It is representative of the early age of gasoline retailing, when filling stations were introduced to the roadside as little domestic cottages or bungalows similar to the ones being built at the nascent suburban edge of town. The canopy served as shelter from the weather for the attendant and customer until the increased size and volume of automobiles after World War II made them functionally obsolete.

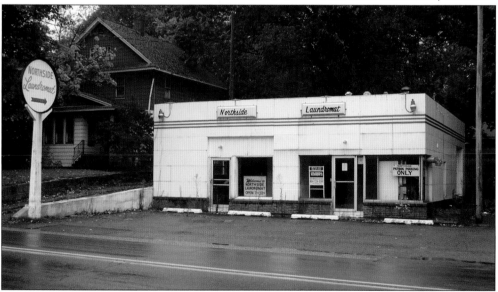

After World War II, the oblong box service station, clad in white porcelain enamel panels with service bays and a corner office, became the icon of the modern roadside. They were built by the thousands and lasted a generation. With the rise of the convenience store gas station in the 1970s, the oblong box faded from the roadside. Meadville's Northside Laundromat on Baldwin Street is a repurposed Texaco station, as defined by the unique place-product packaging gasoline retailers used to distinguish their brands. The round sign and three green stripes were signature details used by Texaco.

The telltale arc of concrete slab road repurposed as a driveway is the story of route succession where first-generation improvements might be little more than hard surface paving followed by a wider realignment with a more extensive use of fill. This US 6/19 remnant is north of Meadville on the Baldwin Street Extension.

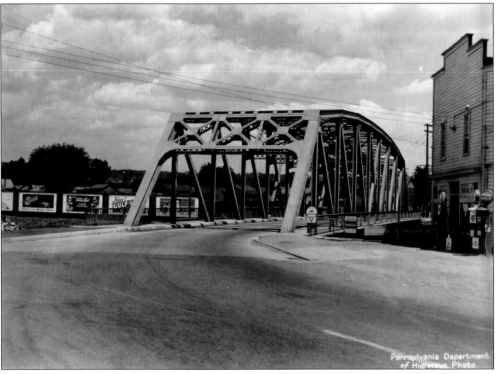

Eastbound traffic on US 6 and northbound traffic on US 19 entered Meadville over the Mercer Street Bridge across French Creek when this Pennsylvania Department of Highways photograph was taken in 1933. Routes 6/19 were relocated to the four-lane Smock Memorial Bridge when it opened in 1950. The store on the right was a wagon shop as late as 1922, updating with the addition of gas pumps by 1932 and then losing them to a service station built across the street by 1947. (PHMC.)

Route 6 in the open countryside west of Meadville in the 1930s is seen here. The old, narrow concrete slab road had minimal shoulder space with white paint on the trees and utility poles to help motorists navigate the road at night, the way guardrail reflectors and the white edge lines do now. (PHMC.)

The widening of Route 6 west from Meadville began in 1950 with the opening of the Spock Memorial Bridge over French Creek and the Erie Railroad. Construction continued west from there until the entire road to Conneaut Lake was four-lane by 1956.

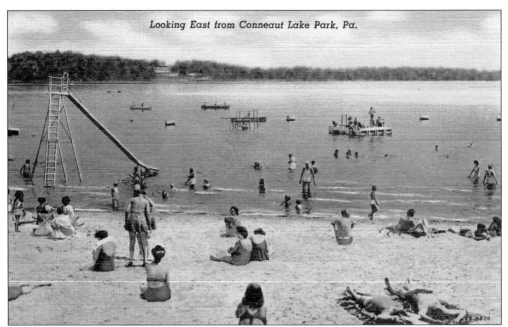

Looking East from Conneaut Lake Park, Pa.

Conneaut Lake Park was founded as Exposition Park 1892, tied to the Bessemer & Lake Erie Railroad and the Meadville & Conneaut Lake electric interurban. After World War II, most visitors came by automobile on Route 6. Amusement rides have included several roller coasters, such as the Jack Rabbit and the Blue Streak, built in 1938. (Curt Teich postcard.)

Pennsylvania Route 18 split north from US Routes 6 and 322 at the old Conneaut Lake wye. A gas station occupied the triangle in the middle of the wye from the 1930s. Still intact on Old State Road, the intersection was bypassed about 1956 when the four-lane US 6/322 reached the shores of Conneaut Lake.

Halfway points between New York and Chicago are marked above on Route 6 in Linesville and below on the old Erie Railroad in Cambridge Springs. Erie Railroad officials, in town for a convention, erected the Cambridge Springs monument a block west of the Route 6 grade crossing in 1924. A Linesville resident threw up his signboards more recently, despite the fact that US 6 does not go to either New York or Chicago. Nonetheless, the idea of being halfway between two of the largest cities in the country allows little Linesville to make this point of pride.

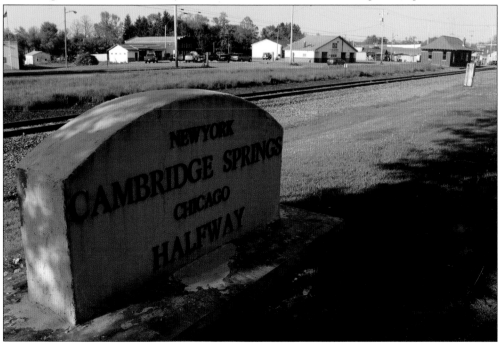

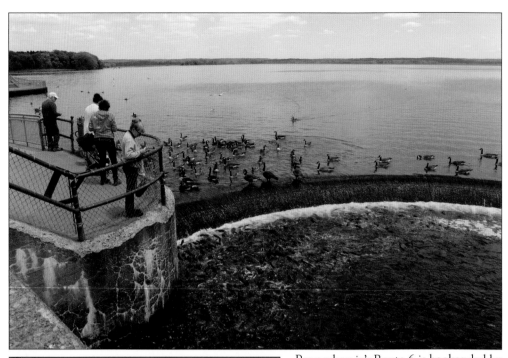

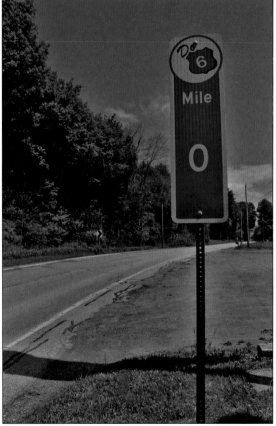

Pennsylvania's Route 6 is bookended by the reservoirs of Lake Wallenpaupack in the east and Pymatuning Lake in the west. Completed in 1934, just south of Linesville, Pymatuning Lake is oddly advertised as the place "where ducks walk on fish." It has been a decades-old custom to throw bread to the carp that gather at the spillway, which also attracts ducks that walk over the fish to get the bread. People throng to the spillway to experience this one-of-a-kind Route 6 attraction.

The crossroads village of Pennline on the Ohio border is Mile 0 for US 6 in Pennsylvania. For eastbound travelers about to "Do 6," this is the beginning of a 365-mile adventure to the Delaware River. Designated by *National Geographic* magazine as "one of America's most scenic drives," Route 6 is a destination to be experienced.

Four

ROUTE 6 TOWNS

Route 6 settlements were initially carved from the wooded wilderness as market towns and county seats along the great East-West Road built across northern Pennsylvania in the early 19th century. The isolated towns filled out after the railroads arrived to aid in the removal of the region's resources: timber, coal, petroleum, and sandstone. Trackside factories edged the towns, turning timber to lumber and lumber to furniture; hemlock bark to tannin and hides to leather; coal to heating fuel; petroleum to kerosene, lubricating oil, and gasoline; and sandstone to sand and sand to glass.

The automobile inherited and modified towns made by the railroad that by the mid-20th century had developed a geography that included three distinct neighborhoods represented by street archetypes: the commercial downtown "Main Street," the upscale residential "Elm Street," and the industrial "Mill Street," with its attendant working-class neighborhood. The appearance of Main Street was infinitely varied, but always contained a government component, business district, retail district, and tourist services. In the 10 county seats US 6 passes through in northern Pennsylvania, the county courthouse is still the civic heart of Main Street, but every incorporated borough has a municipal building complex to house government offices, police, and possibly the fire department.

The mid-20th-century Main Street business district was anchored by local banks, which by the early 20th century had adopted the Neoclassical cloak of columns, pediments, and domes to project a sense of stability, strength, and dignity. These anchor banks also built commercial block buildings in towns large enough to support more business. Banking functions would typically occupy the ground floor of a three-to-five-floor commercial block with the remaining space rented to professionals like dentists, doctors, and lawyers or to house the offices of local businesses. In the largest towns, certainly Scranton but also Warren, Meadville, and even Carbondale, banks invested in mini-skyscrapers between 1890 and 1930. These structural steel framework buildings rose between five and ten stories on narrow downtown lots. Fraternal organizations like the Masons and Independent Order of Odd Fellows were also fixtures of the business district, building commercial blocks containing rented offices and even auditorium event space to help defray the cost of the building's lodge space.

Before the age of suburban shopping malls and big-box retailers on the edge of town, the town's Main Street retail district was anchored by local department stores augmented by junior department store chains like Woolworth's, McCrory's, and G.C. Murphy's. Other retailers such as jewelers, shoe shops, clothing stores, pharmacies, hardware stores, and luncheonettes filled the intervening storefronts. Main Street was also the pre-auto interface between locals and

out-of-towners who arrived at the downtown railroad depot, which had to be within walking distance of lodging. Boardinghouses offered cheap rented rooms, while tourist homes on the downtown edge of the residential neighborhoods provided more comfortable accommodations with meals. Moderately priced downtown hotels stood proximate to Main Street, with the most exclusive lodging provided by the town's flagship hotel. Prominently located, the flagship hotel also contained the town's better restaurant and most respectable taproom. These hotels, with their spacious, well-apportioned lobbies, functioned as the social hubs of the towns and sometimes contained ballrooms and a local radio station.

Before the dominance of the automobile, the upscale neighborhoods with the largest, most architecturally detailed houses were centered on the main roads leading into town, as well as being proximate to the courthouse in the county seats. If the courthouse faced Main Street, the upscale Elm Street favored the residential neighborhood behind the courthouse. Elm Street neighborhoods housed the families of well-paid professionals like judges, lawyers, merchants, doctors, and the owners of local businesses and factories. Elm Street neighborhoods were also likely to contain a town's largest, oldest, and most prestigious churches housing the denominations of the business class. In Pennsylvania, this invariably meant a Presbyterian church and likely a Methodist, Lutheran, and possibly a Baptist church, but only occasionally a Catholic church and rarely a synagogue, despite the fact that many of the downtown stores had Jewish owners.

Main roads leading into town were initially attractive homesites for the wealthy because these streets were likely to receive amenities first—like paving, sewer and water service, gas and electric utilities, telephone lines, and streetcars. It was the noise, smoke, dust, and dirt of cars and trucks that made these streets less than desirable. In the mid-20th century, however, these main road Elm Streets were viable, with the houses still in the possession of those who had owned them—or even built them—some 30 years before. Selling these large homes to a new and potentially less prosperous generation would be more challenging. As the principal main road, US 6 took on the function of an upscale Elm Street on either end of each town it went through, transitioning into a commercial Main Street in the downtowns.

Route 6 typically skirted the working-class Mill Street neighborhoods, passing factories and crossing railroad tracks at the edge of town. The working-class families of Mill Street lived within walking distance of trackside factories in modest, vernacular houses intermixed with corner grocery stores, bars, social clubs, small repair and fabricating shops, and the occasional unassuming church. The land beyond the edge of town in the pre-auto past was farm-studded countryside all the way to the edge of the next town. By the mid-20th century, however, an auto-oriented commercial strip of gas stations, motels, roadside restaurants, custard stands, and drive-in movie theaters replaced the hard edge between the last townhouse and the first country barn with a tattered fringe of ad hoc development that trailed off into a quasi-farmland fronted by the occasional crossroad filling station or cornfield-cornered cabin court.

This was the pattern of Pennsylvania's Route 6 in the mid-20th century, the idyllic peak of the small town when most people had access to an automobile but before the complete collapse of the railroads and subsequent deindustrialization of the Mill Street neighborhoods. This was when locally owned department stores were a fixture of every county seat Main Street, but before suburban shopping centers devastated the downtown retail districts. This was when the new growth at the edge of town was thought to be a progressive addition to the downtown rather than its replacement; when local businesses were headquartered in the downtown commercial block buildings owned by local banks rather than in bypass business parks—if not well beyond the borders of the state. Although Route 6 towns have been altered by these changes, their effect on the built environment has not been as dramatic as it has in other American towns much closer to metropolitan regions and interstate highways than this main road across northern Pennsylvania. Here, the mid-20th century landscapes have lingered a little longer, affording the motorist a peak at a past not entirely swept away.

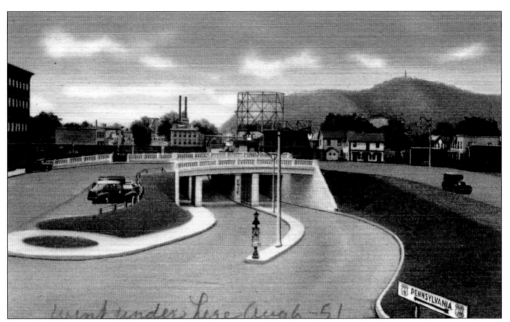

In this photograph, Route 6 runs west to Pennsylvania and the Pocono Plateau (in the distance) from Port Jervis, New York. The interface between modern highways and downtowns was already changing by the 1930s, as evidenced by the routing of US 6 away from downtown Port Jervis and through this grade separation subway beneath the Erie Railroad. (Tichnor.)

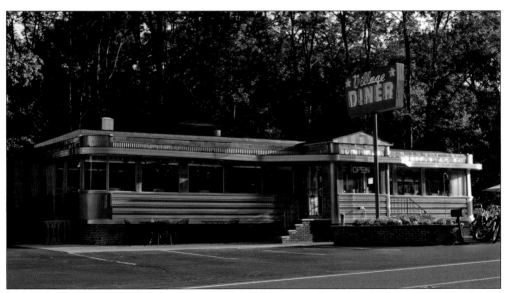

Diners became a fixture of Main Streets by the 1920s, especially in towns closer to the New Jersey diner-manufacturing plants. As the automobile exerted more influence, diners like the Village Diner shifted to edge-of-town locations. The epitome of midcentury modernity, this 1956 stainless-steel diner manufactured by Mountain View was located east of Milford by the Musselwhite family, who previously ran three generations of downtown Milford Diners dating back to 1927.

The Hawley Diner arrived at the downtown intersection of Main Avenue (US 6) and Keystone Street in 1954. The year it arrived, downtown Hawley had all the elements of a classic small town. Two banks anchored the other Main and Keystone corners, Krawitz's Department Store was a few buildings down on Main, the Hawley Inn was at Main and Church Street, and the Ritz Theater was a half block east on Keystone.

Banks built in the early 20th century favored the Neoclassical architectural style. Three Honesdale banks line up on Main Street in the short block between Seventh and Eighth Streets where the Delaware & Hudson Canal turning basin was filled in around 1895. The corner Honesdale National Bank was built in the Romanesque Revival style in 1896, followed by two Neoclassical banks in the 1920s.

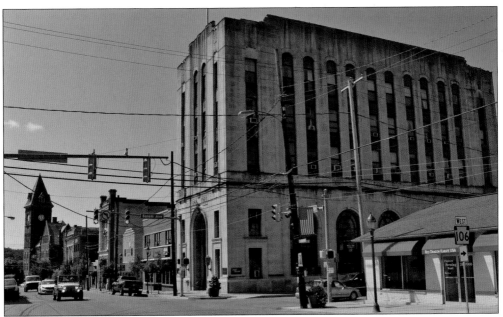

The next step up for business districts in larger industrial towns expanding during the early 20th century was for banks to erect mini-skyscrapers like the First National Bank Building in Carbondale. It was erected in 1928, the year US 6 was routed down Main Street. Local Carbondale industries that fueled the expansion of the downtown at this time included anthracite mines, textile mills, and the Delaware & Hudson Railroad shops.

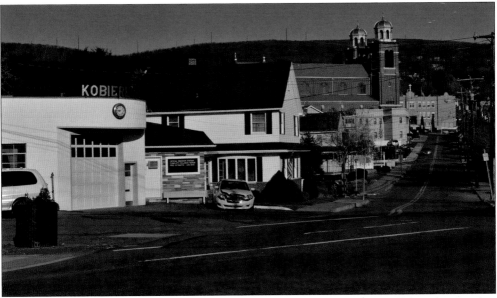

Before US 6 was relocated in 1941, it went through a string of Lackawanna Valley coal towns that included Dickson City, shown in this view looking west on Dundaff Street from Main Street (old US 6). This working-class neighborhood was established as a Polish community of miners and mill workers whose ethnicity is still imprinted on the landscape through the Kobierecki repair garage, the Romanesque Revival–style Visitation of the Blessed Virgin Polish Catholic Church consecrated in 1911, and the St. Mary's Catholic school, now LaSalle Academy, opened in 1925.

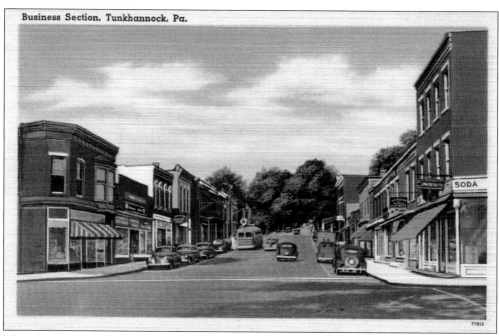

Business Section, Tunkhannock, Pa.

Main Streets in smaller Route 6 towns, like Tioga Street in Tunkhannock, retained their original two-story, Italianate retail shops. This view looking west along US 6 around 1940 shows the corner luncheonette and a stopped intercity bus. Prior to this time, the interface for most travelers to and from Tunkhannock would have been the Lehigh Valley Railroad depot, located a block west. (Tichnor.)

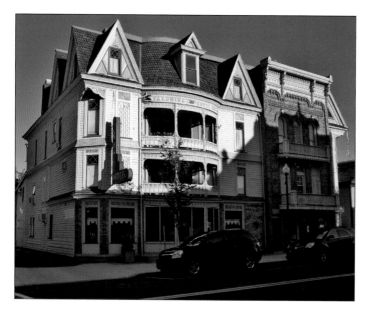

The Wyalusing Hotel, just off Route 6, has been at the heart of Wyalusing for over 100 years. Founded in 1860 as the Brown Hotel, the facility now includes a restaurant, along with several historical items from the early 20th century, including photographs and guest registers. The gingerbread features of the hotel were styled by architect/contractor J. Morgan Brown, who designed several other buildings in the Wyalusing area.

Since the East-West Road was built in the early 19th century to connect the county seats along the northern tier of Pennsylvania, county courthouses have played a prominent role in nine Route 6 county seat downtowns. The Bradford County Courthouse in Towanda was built in a Neoclassical style between 1896 and 1898. The dome supports a statue of Justice, and the lawn features a Civil War monument dedicated in 1905.

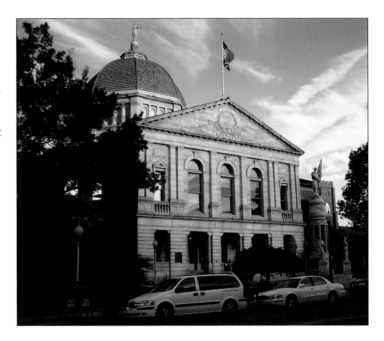

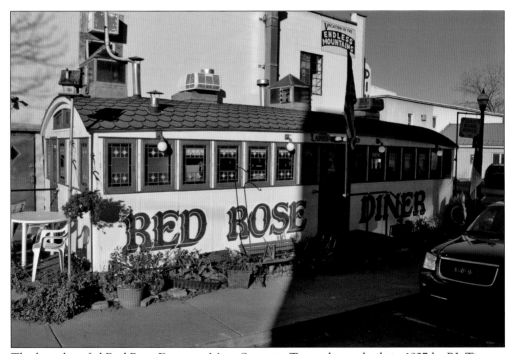

The barrel-roofed Red Rose Diner on Main Street in Towanda was built in 1927 by P.J. Tierney Sons Inc., of New Rochelle, New York, and transported to Stroudsburg, Pennsylvania, where it spent most of its life as the Lackawanna Diner. Saved and restored in 1999, it was relocated to Towanda as the Red Rose in 2003.

All of the larger towns on Route 6 have an Elm Street of larger homes built by local merchants and professionals in the late 19th and early 20th centuries, like York Avenue in Towanda. In many cases, this Elm Street is the outer, residential margin of Main Street, subsequently followed by Route 6 traffic passing through town.

Wellsboro's Main Street has been anchored by the Penn-Wells Hotel since 1926. The hotel retains much of its neon, including a rooftop sign, and an auto entrance sign. The adjacent Arcadia Theatre opened in 1921. Theater manager Larry Woodin also built the Y Drive-in Theater on Route 6 at Pennsylvania Route 660, which operated between 1952 and 1986. The visual continuity between the Penn-Wells and Arcadia Theatre is maintained by the Wellsboro Hotel Company that now owns them both.

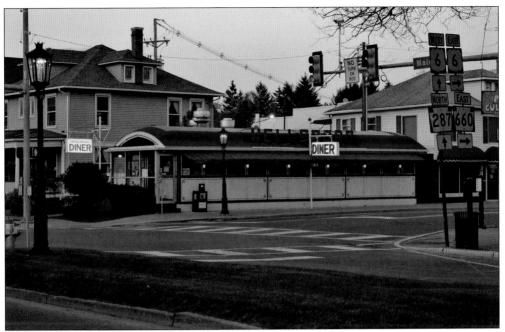

Route 6 intersects with Wellsboro's Main Street at the Wellsboro Diner. This light-green, barrel-roofed gem covered in porcelain enamel panels is the only surviving Pennsylvania diner manufactured in New England. The Judkins Company of Merrimac, Massachusetts, built the diner in 1938, and it opened in Wellsboro the following year, replacing an even older diner.

The Osgood auto showroom in Galeton is the best example of a Neoclassical early-auto showroom on Pennsylvania's Route 6. The site was originally occupied by the Edgcomb Hotel's livery stable. The stable was converted into an auto-repair garage that burned on New Year's Eve 1922. This grandiose auto showroom opened on the site the following year. In the Osgood family until the 1980s, the building was most recently an auto parts store.

The lumber towns in northern Pennsylvania were susceptible to catastrophic fires, which did considerable damage in both Galeton and Coudersport. Much of Coudersport's Main Street was destroyed in an 1880 fire, then rebuilt with brick in an Italianate style, which accounts for the similar appearance of the buildings. The Crittenden Hotel on the corner of Second Street (right) was the last to be completed.

Coudersport's Crittenden Hotel, or "the Crit," has been the site of a hotel since 1840. The 1880 fire that destroyed downtown consumed the earlier Glassmire House, which was replaced by the Crit in 1902. Famed crime fighter Eliot Ness spent the last two years of his life in Coudersport. He met with Oscar Fraley at the Crittenden Hotel to frame out their book, *The Untouchables*, published in 1957, the year Ness died of a heart attack. (Curt Teich postcard.)

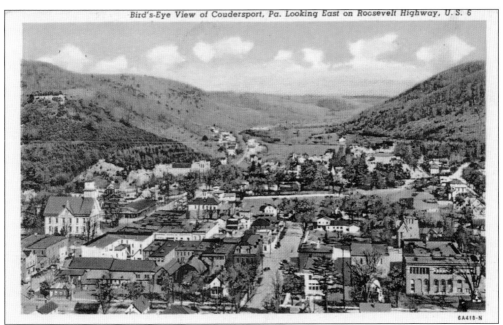

Coudersport is the first large Route 6 town in the Allegheny headwaters west of Denton Hill. This eastward view up Sweden Valley is toward the Allegheny-Susquehanna drainage divide. The larger building on the left is the Potter County Courthouse on Second Street. Crossing the river three times as it meanders through town, westbound Route 6 comes into town on Second Street, turns south on Main Street, and then goes west on Chestnut Street. (Curt Teich postcard.)

In 1937, the Pittsburgh Corning Company established this plant along Route 6 on the western edge of Port Allegany. It manufactured glass blocks, but production declined in the 21st century with a depressed housing market and competition from abroad. In May 2016, the company exited the glass block business and closed the factory, leaving about 75 employees jobless. (Tichnor.)

In Route 6 towns where factories and other industries were established, homes were built to accommodate workers and their families, creating "Mill Street" communities. These vernacular homes on the western edge of Port Allegany were built across the street from the Pittsburgh-Corning Glass plant.

Smethport has all of the elements of a typical Route 6 county seat located within walking distance of its 1938 Route 6 Diner. A Neoclassical bank building is across the street, and the courthouse is one block west; beyond that is the Mansion District, Smethport's historic residential neighborhood. The Route 6 Diner is also the home of the Hubber Burger, a name taken from Smethport's identity as the "Hub of McKean County."

Reflective of the Swedish heritage in the Mount Jewett area, the Mount Nebo Swedish Evangelical Lutheran Church was built in 1887, with the congregation having been established in 1886. Located about one mile west of the center of Mount Jewett, the church building has an octagonal shape designed after Ersta Kyrka at Danviken near Stockholm, Sweden. Scandinavians made up a large part of the labor force in this area during the 19th century.

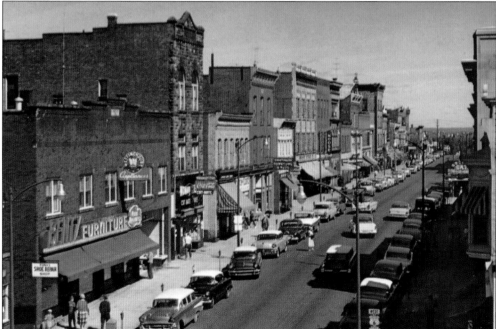

Fraley Street on US 6 in downtown Kane prospered in the mid-20th century from its glass, lumber, and railroad industries. Kane has also functioned as a gateway to the Allegheny National Forest. As depicted by this 1950s street scene, the automobile was well established and the downtown retail district was still viable, not yet impacted by suburban shopping centers.

Shown here under construction in 1907, the six-story New Thompson House in Kane was built at Fraley and Greeves Streets, opposite the Pennsylvania Railroad depot (left) and on the corner where US Route 6 would intersect Pennsylvania Route 66. The New Arlington Hotel and Windsor Hotel were across Fraley Street, creating a nexus of lodging establishments with easy access to railroad and road at the south end of the business district.

Covered in white porcelain enamel panels, this 1930s Streamline Moderne Kendall station was at the forefront of what service stations would look like throughout the mid-20th century. Repine's was at Chase and Fields Streets in Kane, where a smaller, canopy filling station stood in the 1920s. Route 6 was a block away on Fraley Street. The site is now a parking lot for the Texas Hot Lunch across Field Street. (Tichnor.)

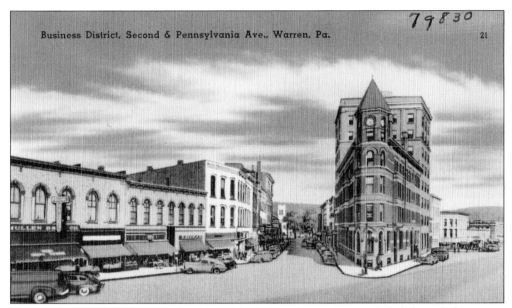

79830

Now on the bypass, US 6 was originally routed on Pennsylvania Avenue (right) through downtown Warren past the clock-towered Warren Savings Bank. The bank, also known as the Flatiron Building, was built at the intersection with Second Avenue in 1891. The mini-skyscraper immediately behind the bank went up in 1927, when Warren's oil-related economy was expanding with the Struthers-Wells Company in the West End and the United oil refinery in Glade. (Tichnor.)

The Blue and White Restaurant - Warren, Pa. 27865

Kitchen

Dining Room

Front

CATERING TO THE PUBLIC FROM COAST TO COAST

This postcard shows C.P. Spiridon's 1925 Blue and White Restaurant at 211 Liberty Street (a block north of Route 6) after a 1937 Streamline Moderne remodel. Many storefront luncheonettes occupying older Main Street buildings like this were modernized during the 1930s and 1940s, maintaining this look into the 1960s. The remodel included an innovation proudly celebrated in a January 21, 1935, *Times-Mirror* newspaper article about the restaurant's new air-conditioning system. (Tichnor.)

TIMES SQUARE SUPER SERVICE STATION
CENTRALLY LOCATED, DOWNTOWN
FREE PARKING
TIMES SQUARE WARREN, PA.

Sterling was Quaker State's gasoline brand from 1923 into the 1960s with service stations throughout northwestern Pennsylvania, like this one on US 6 in Warren. The next-door *Times Mirror* newspaper (left) inspired the Times Square name for the intersection of Pennsylvania Avenue (US 6) and Market Street. The original Times Square Service Station was a Tudor-style cottage that opened in 1932. This three-bay oblong box replaced it after World War II. (John Jakle.)

Hotel Corry, Corry, Pa.

The 1920s was the last decade in which large downtown hotels were being built in relatively small towns. These hotels were oriented to both the railroad and the automobile. The Corry Hotel was built in 1924 at Center Street and Park Place, three blocks north of Corry's Union Station and one block south of where US 6 turned from Center Street to go west on Smith Street. The Corry Higher Education Council has occupied the old hotel since 1991. (Curt Teich postcard.)

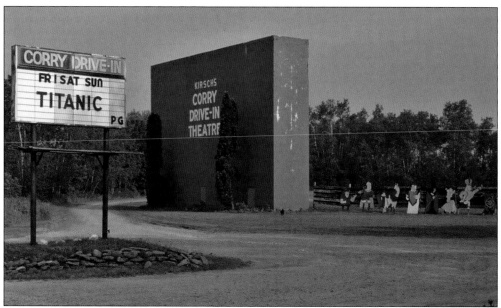

Like the ship *Titanic*, most drive-in theaters have disappeared. The Corry Drive-In opened on Route 6 halfway between Corry and Union City in 1952 and survived until 2011. The theater could handle up to 300 cars and was one of several Blatt Brothers drive-ins scattered throughout western Pennsylvania. Most towns in the post–World War II period had one or more drive-ins on their peripheries, but few remain.

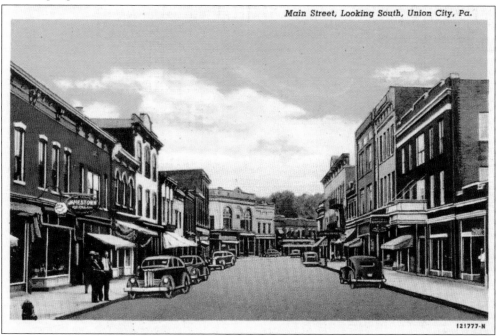

In this 1950s view, westbound US 6 goes south through downtown Union City, past such Main Street institutions as the Union City Dinor (out of view to the right, and using the unique Erie spelling of *diner*), Congdon Hotel (front right), Rice Hotel (rear right), the Rexall Drug store in the IOOF Lodge (in the dogleg left), and the Palace Theater (end of street left).

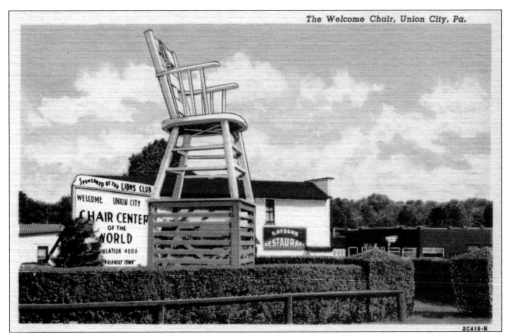

This 1952 postcard shows the Lions Club "Welcome Chair" in downtown Union City, attesting to the fact that the mills at the edge of this town were chair factories: Union City Chair (starting in 1881), Standard Chair, and Shreve Chair were the largest, with Union City Chair lasting the longest, closing in 2000. The big Welcome Chair was itself dismantled decades ago. (Curt Teich postcard.)

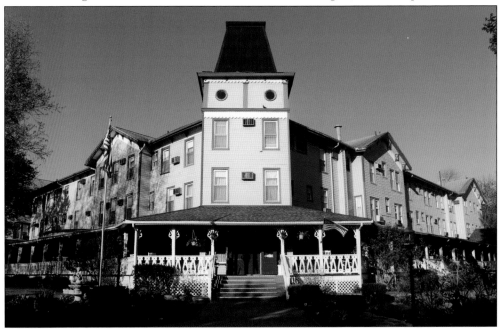

With the opening of the Riverside Hotel in 1888, Cambridge Springs became a mineral springs resort served by the Erie Railroad and the electric interurban from Erie and Meadville. When US 6 was routed through Cambridge Springs in 1931, the mineral springs era was essentially over, and the Great Depression was on, but the Riverside Hotel would survive to the present day.